DOUG THE PUG

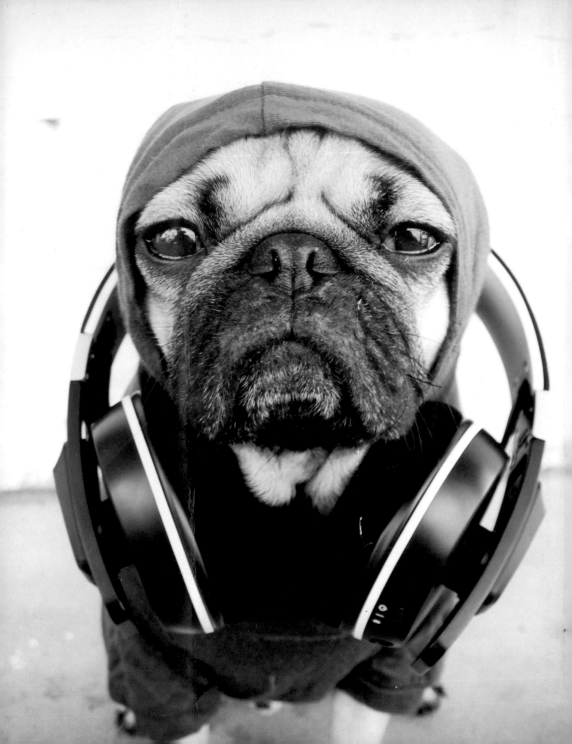

DOUG THE PUG

KING OF
THE INTERNET

LESLIE MOSIER

BOXTREE

First published 2016 by St Martin's Griffin

First published in the UK 2016 by Boxtree,
an imprint of Pan Macmillan
20 New Wharf Road, London N1 9RR
Associated companies throughout the world
www.panmacmillan.com

ISBN 978-0-7522-6603-9

3 5 7 9 8 6 4

A CIP catalogue record for this book is available from the British Library.

Printed and bound in China

Visit **www.panmacmillan.com** to read more about all our books
and to buy them. You will also find features, author interviews and
news of any author events, and you can sign up for e-newsletters
so that you're always first to hear about our new releases.

To my parents. Thank you for cultivating my creativity, giving me my first camera, and supporting me on whatever crazy endeavor I chose to take on. I love you.

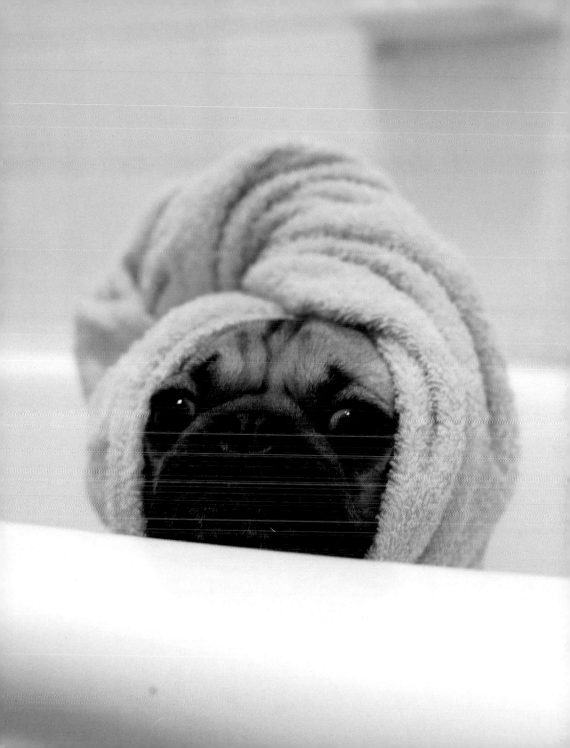

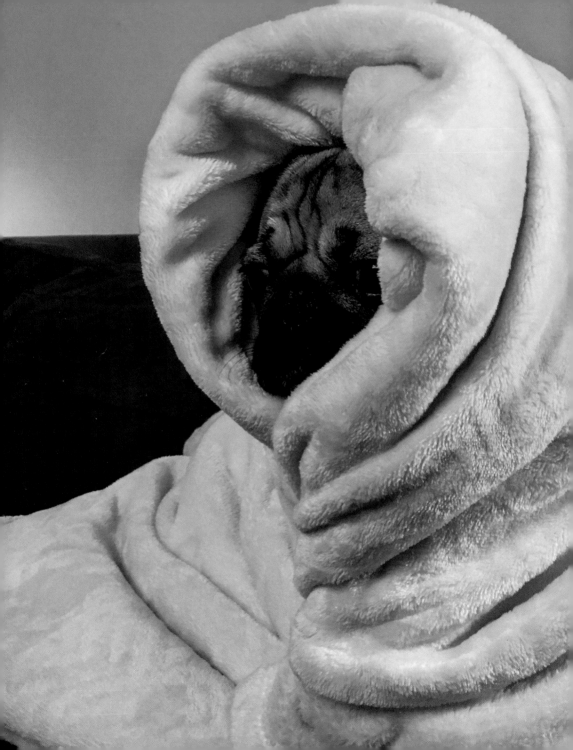

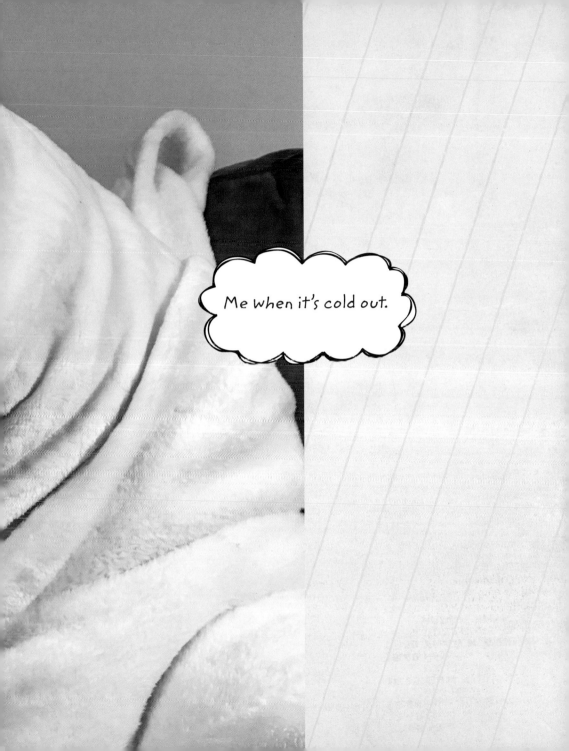

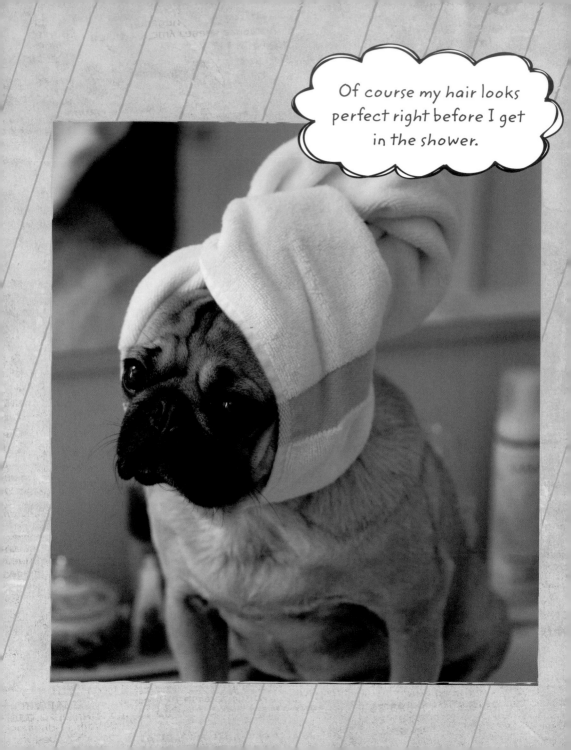

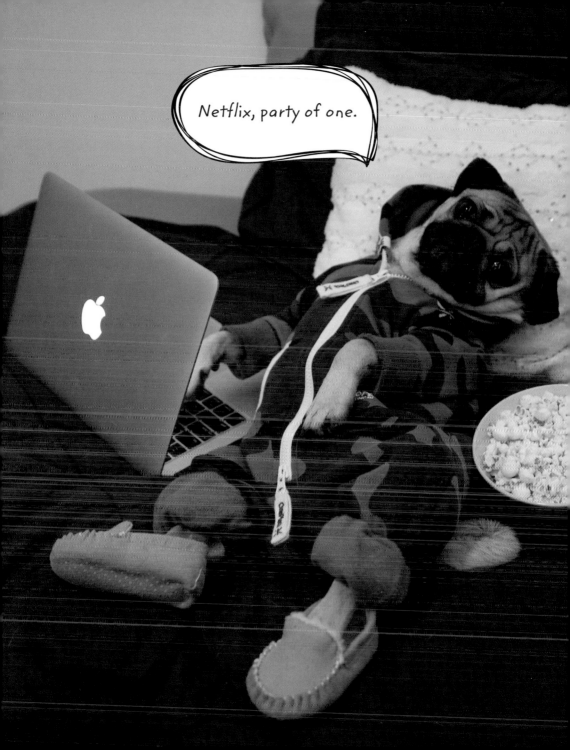

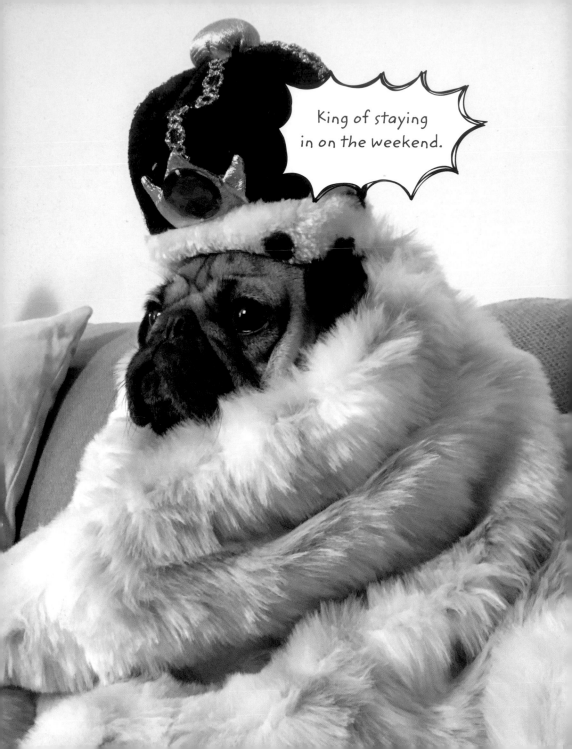

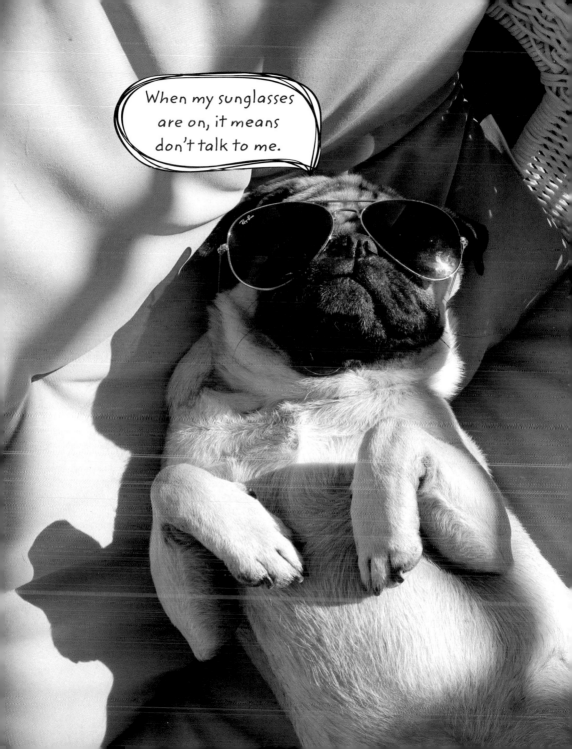

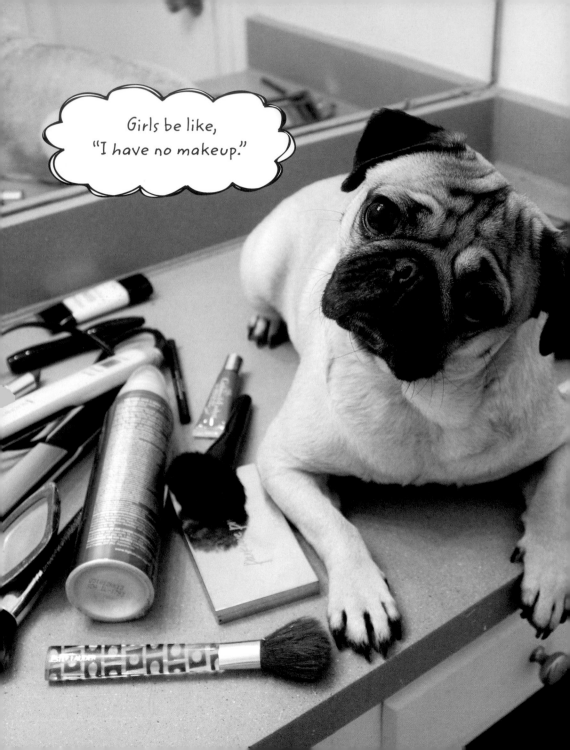

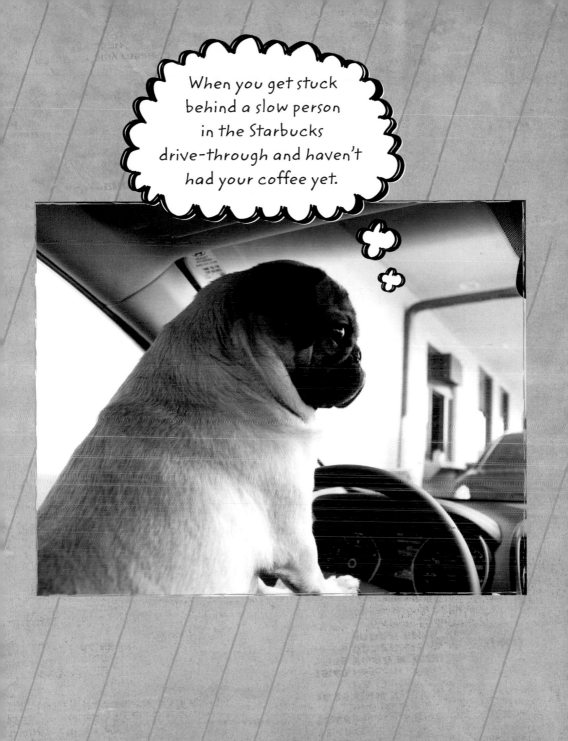

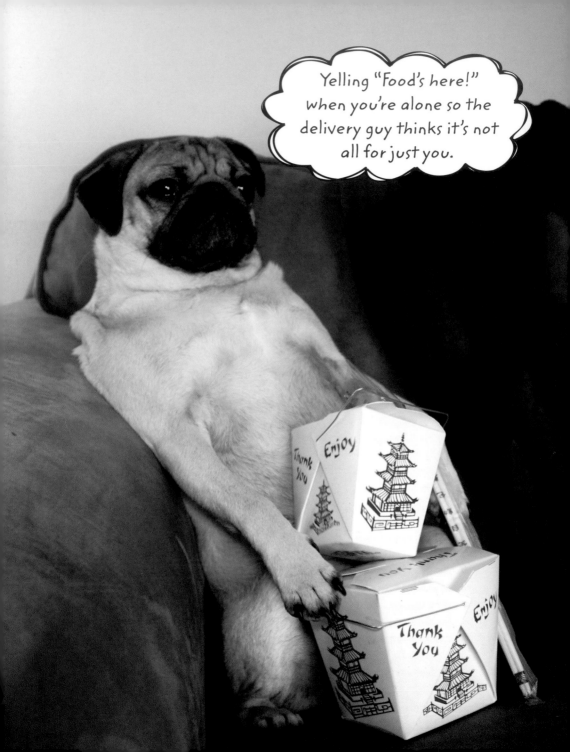

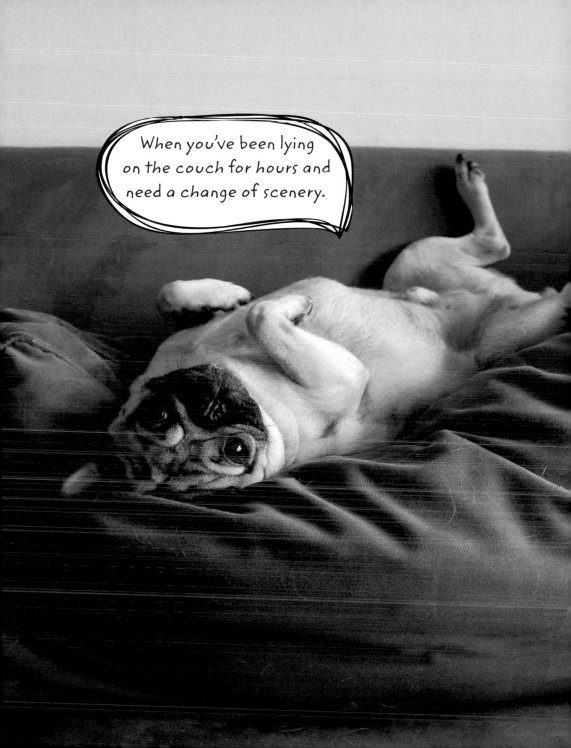

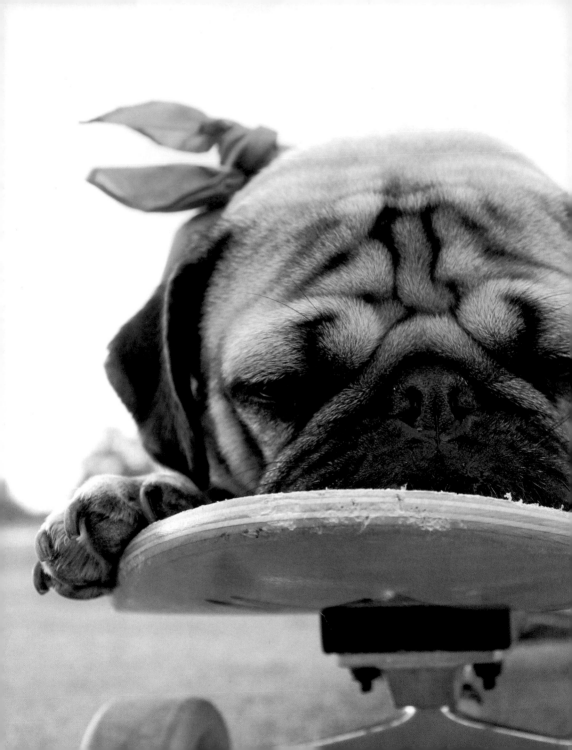

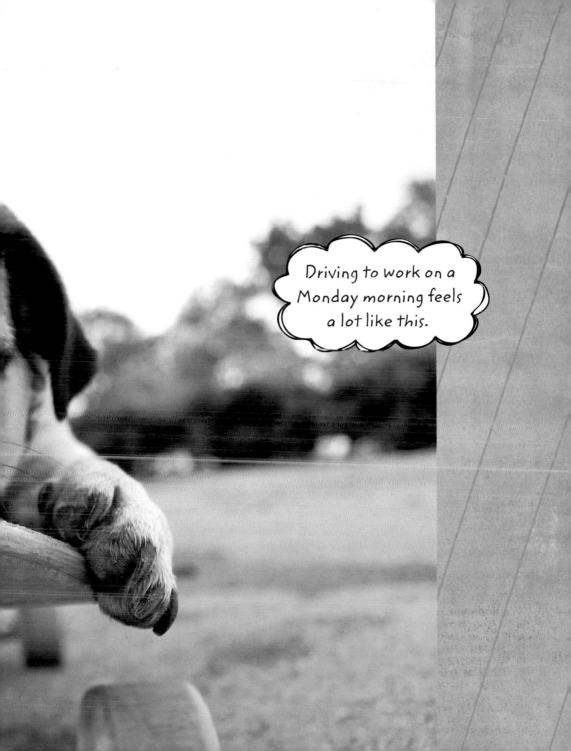

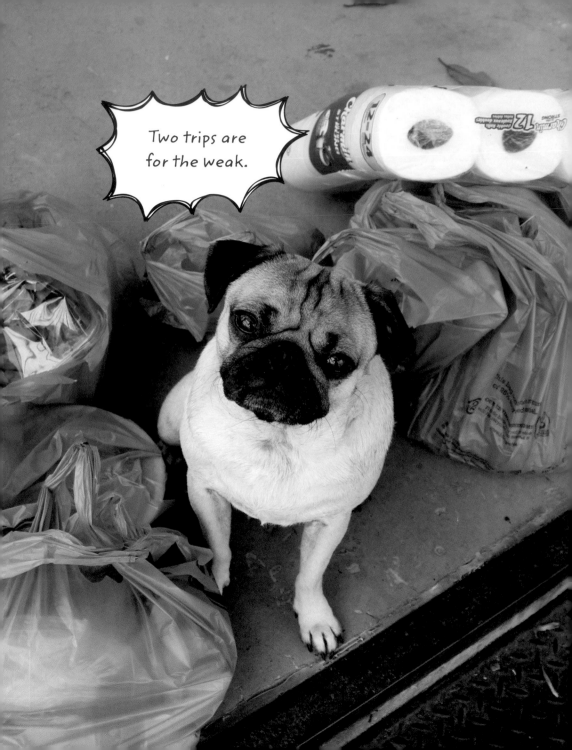

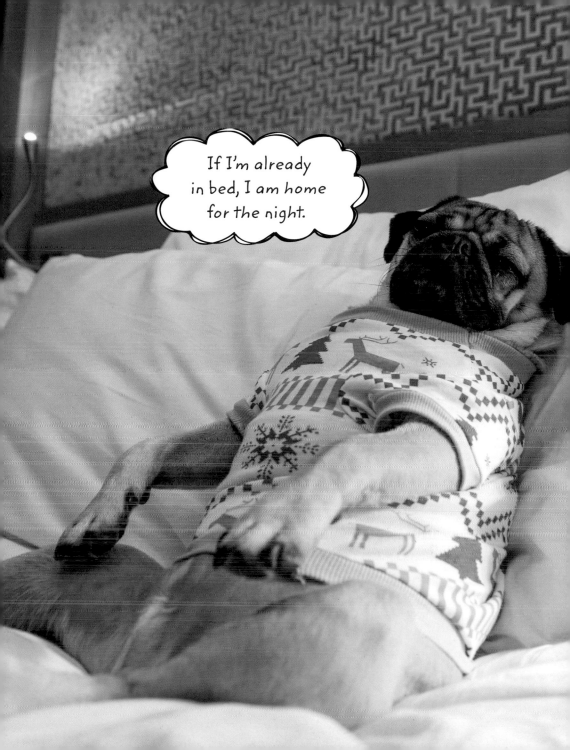

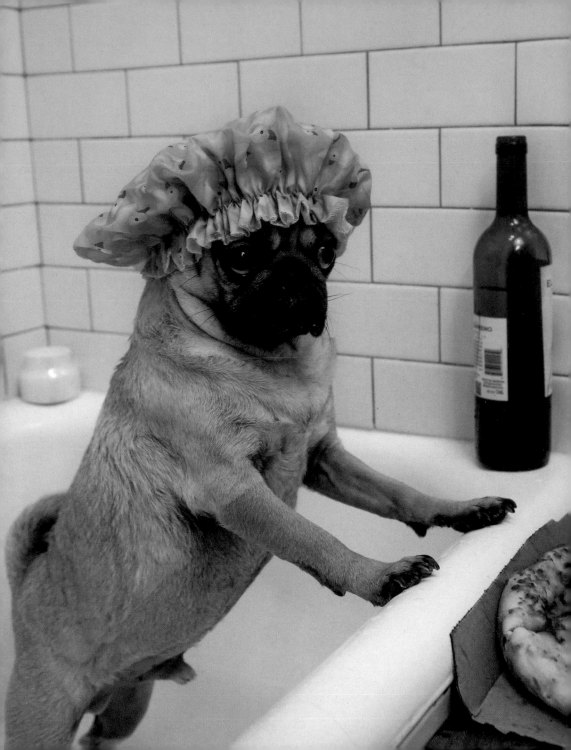

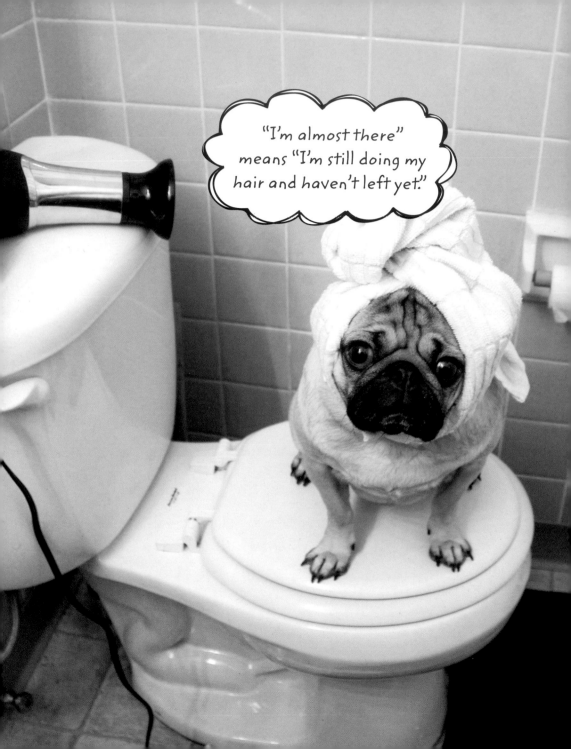

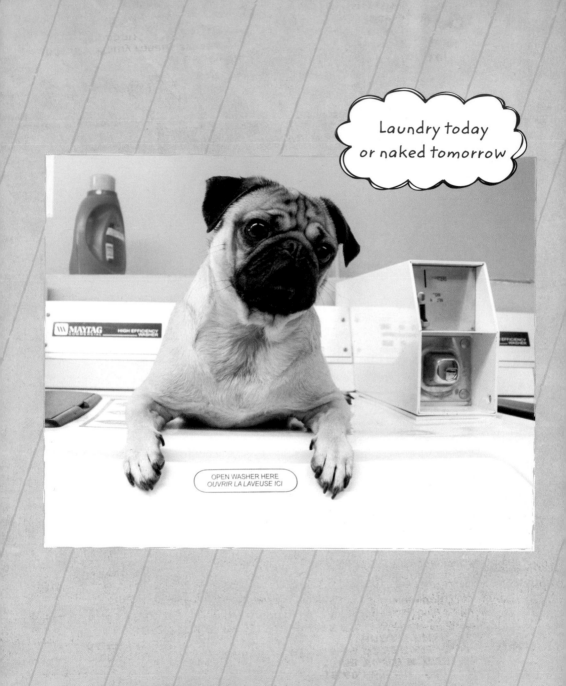

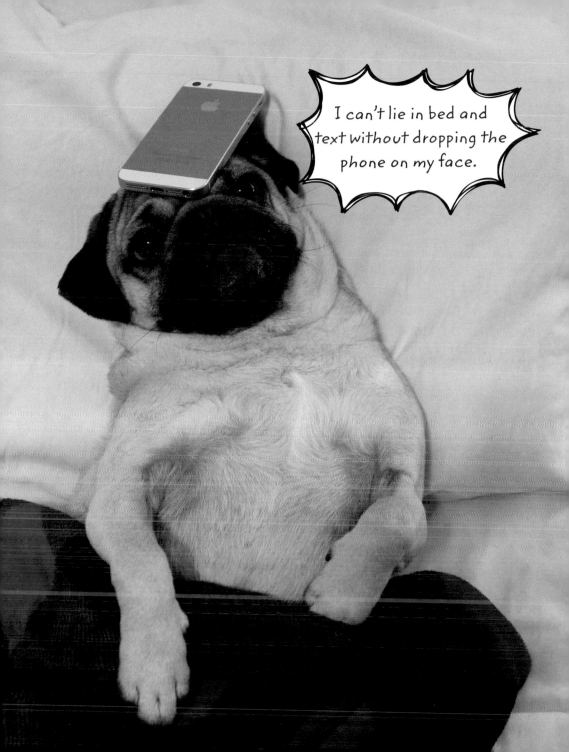

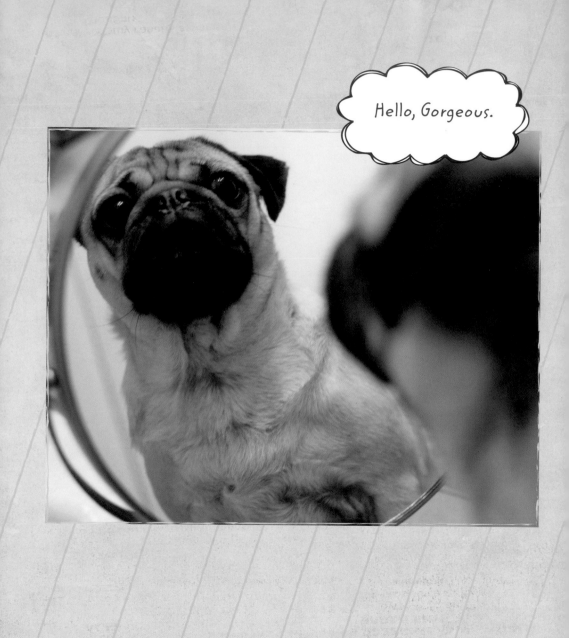

Hello, Gorgeous.

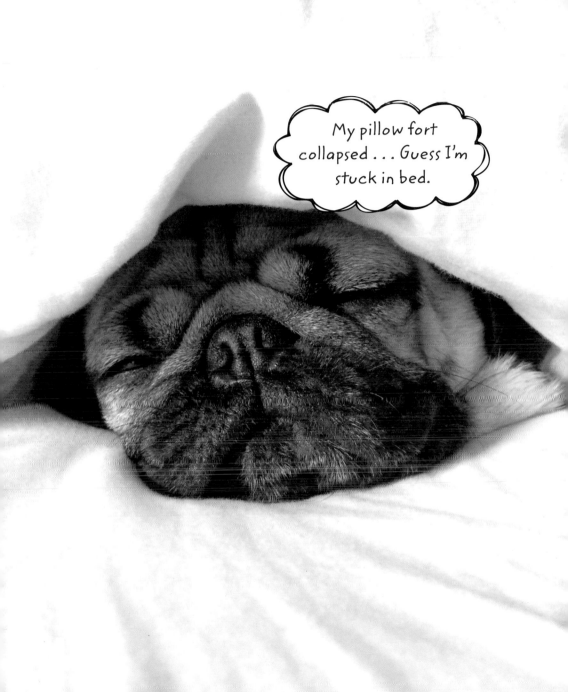

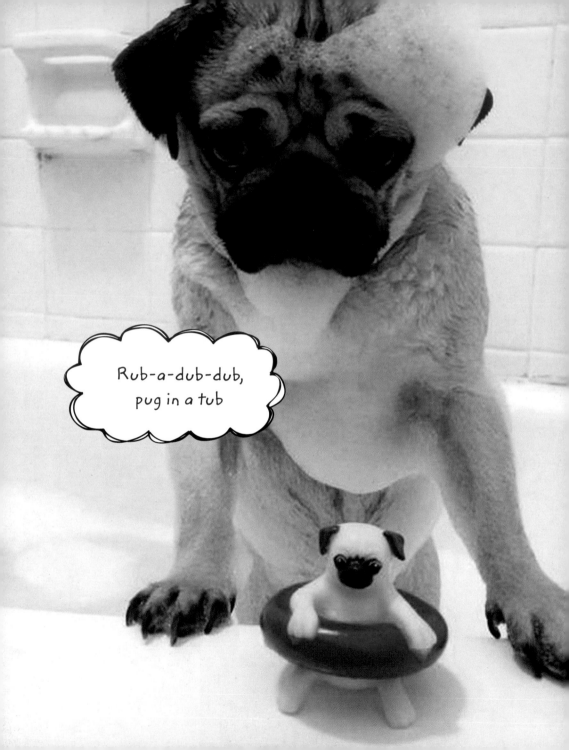

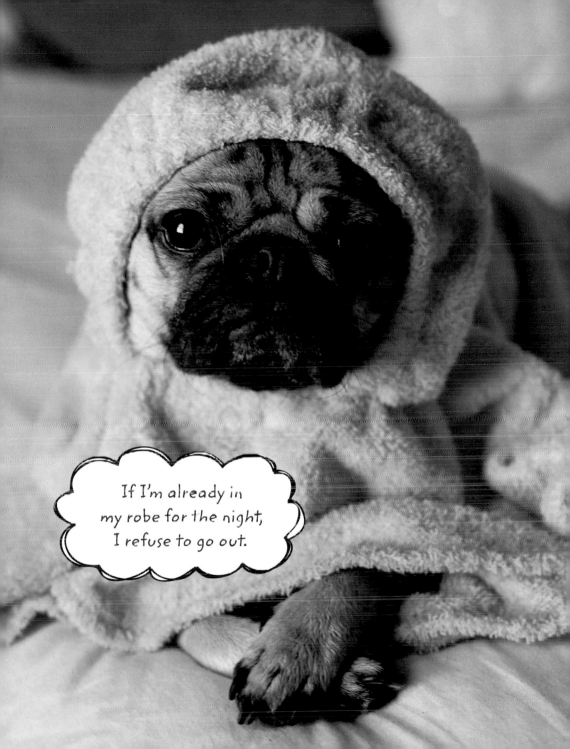

If I'm already in
my robe for the night,
I refuse to go out.

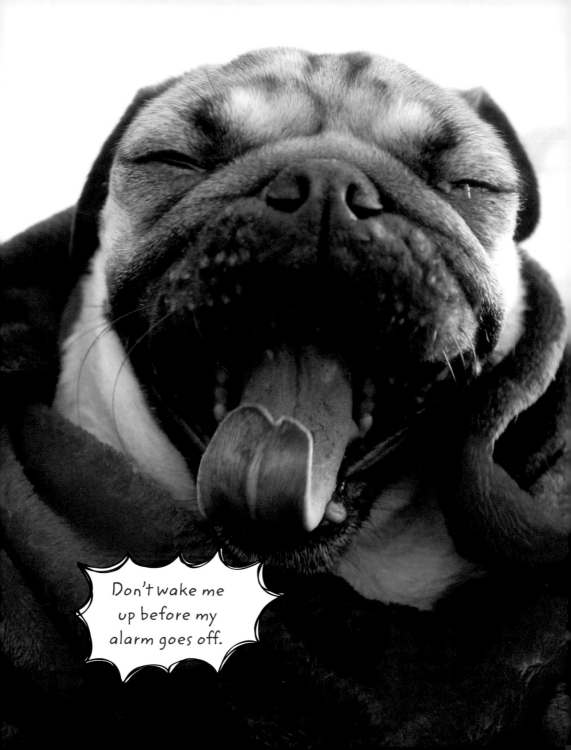

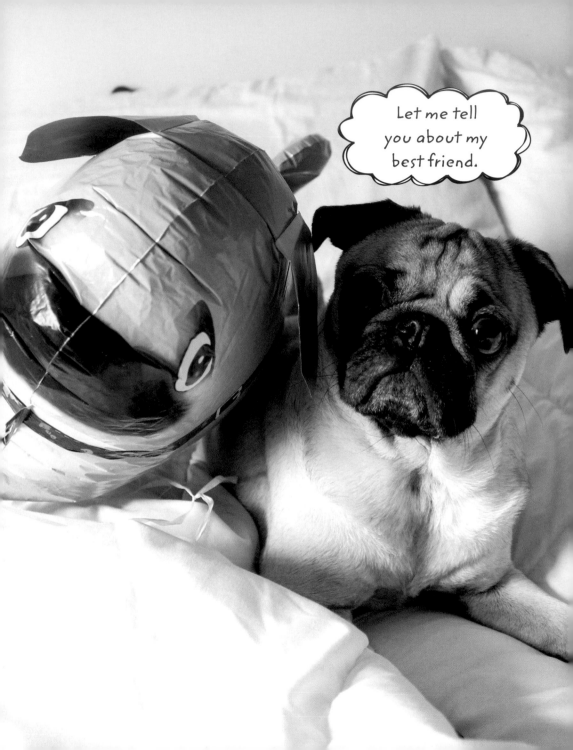

PUG
ON THE
ROAD

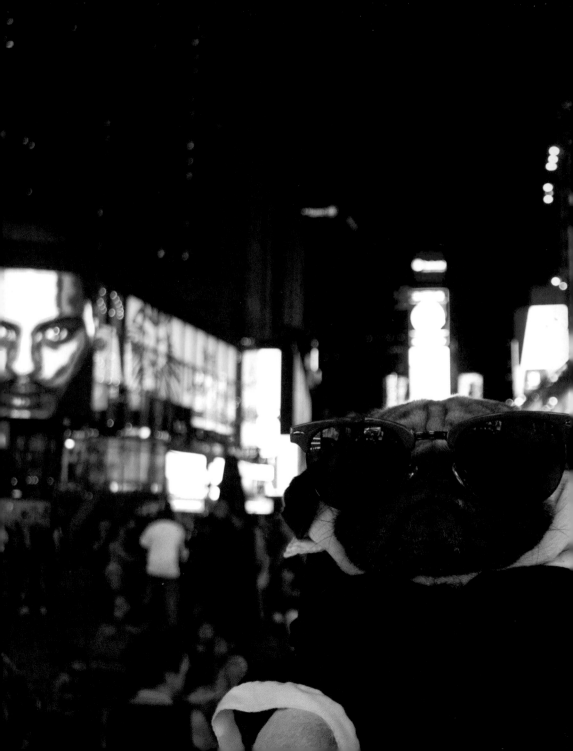

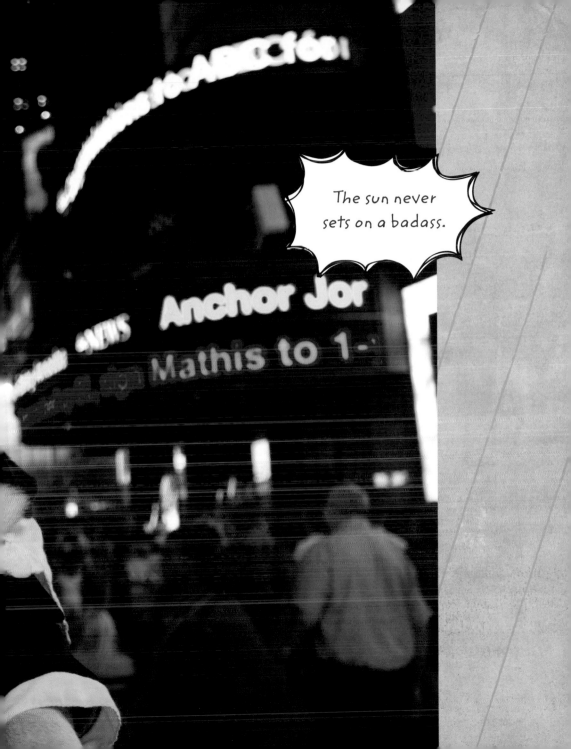

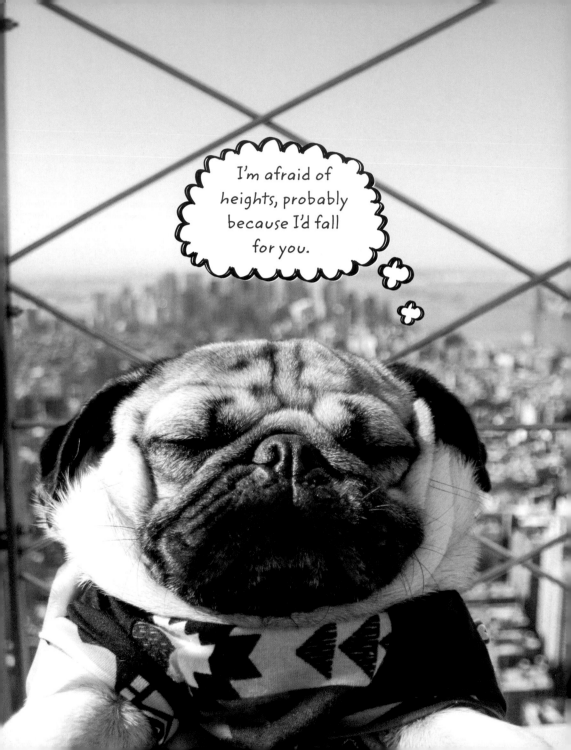

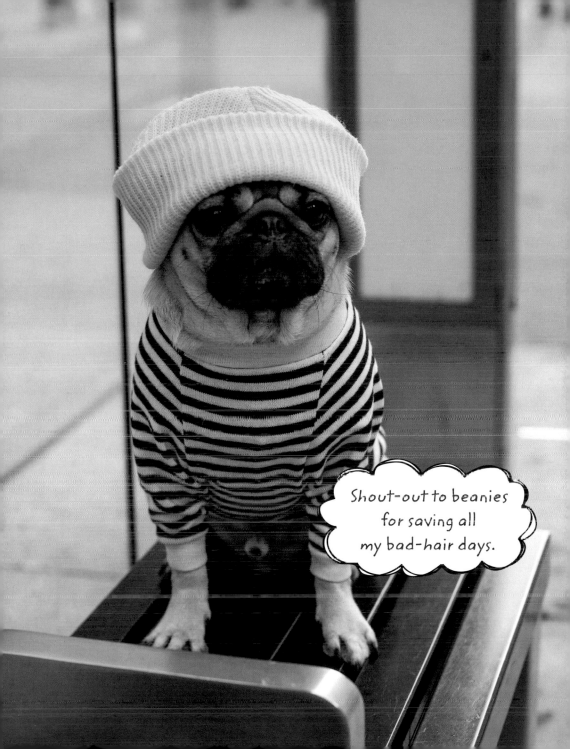

Shout-out to beanies for saving all my bad-hair days.

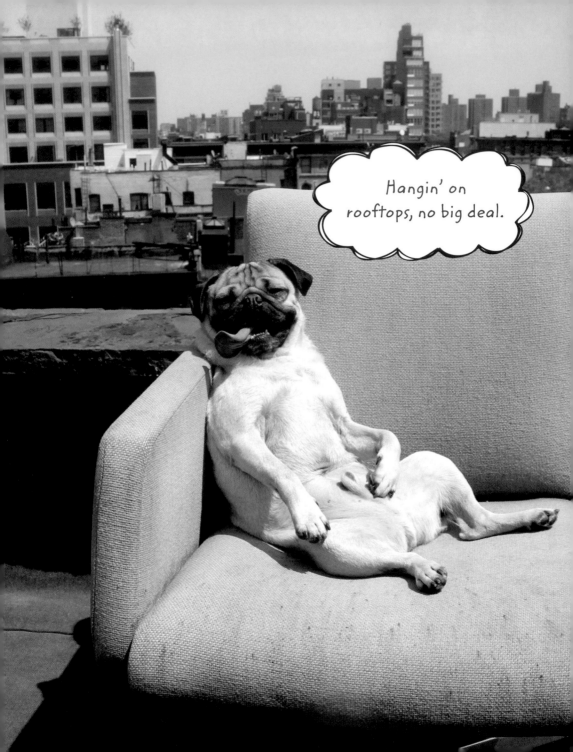

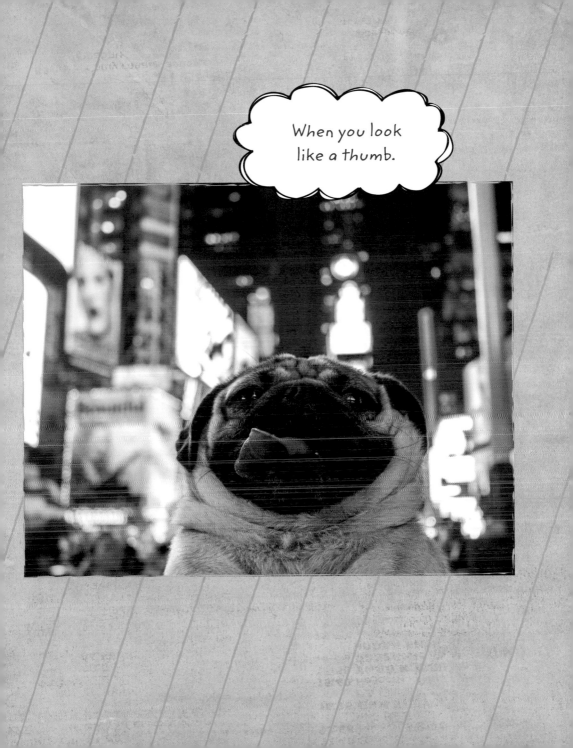

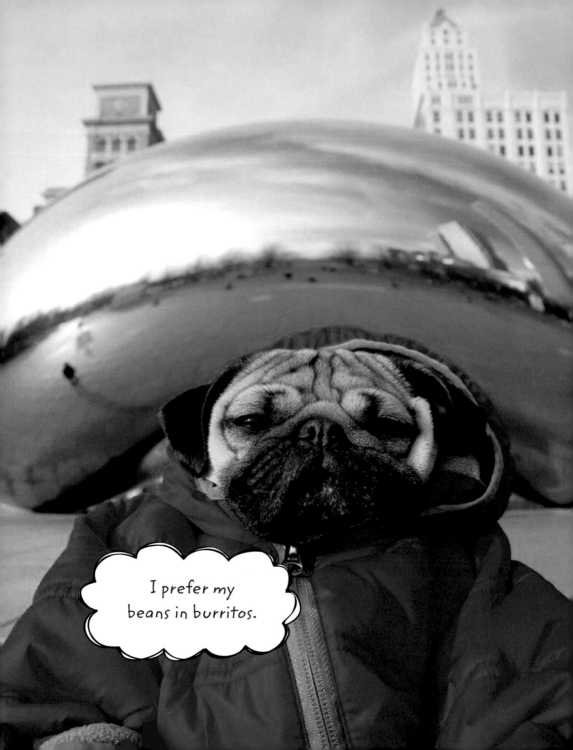

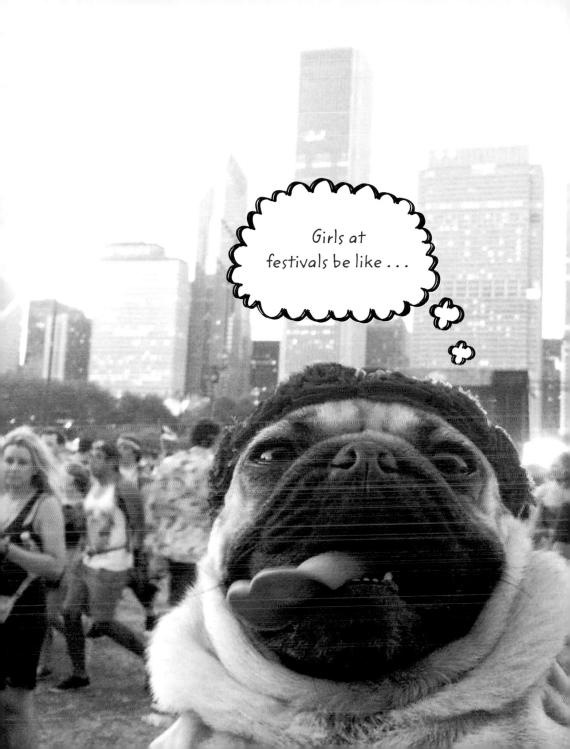

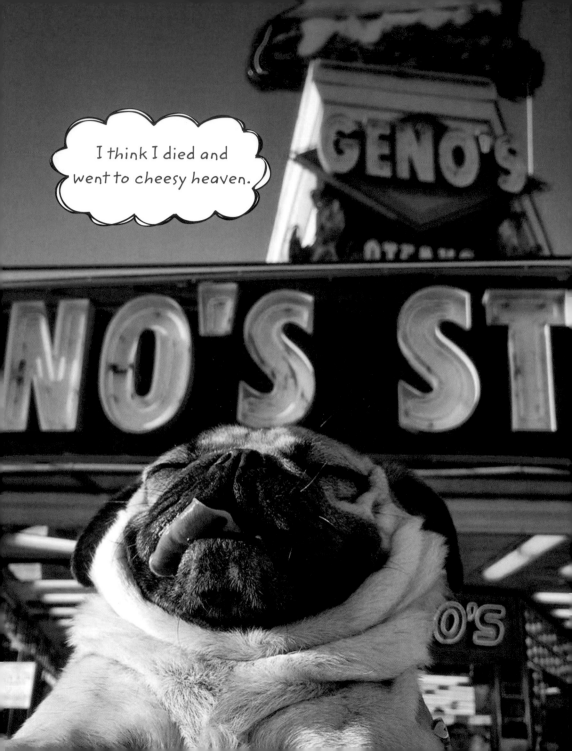

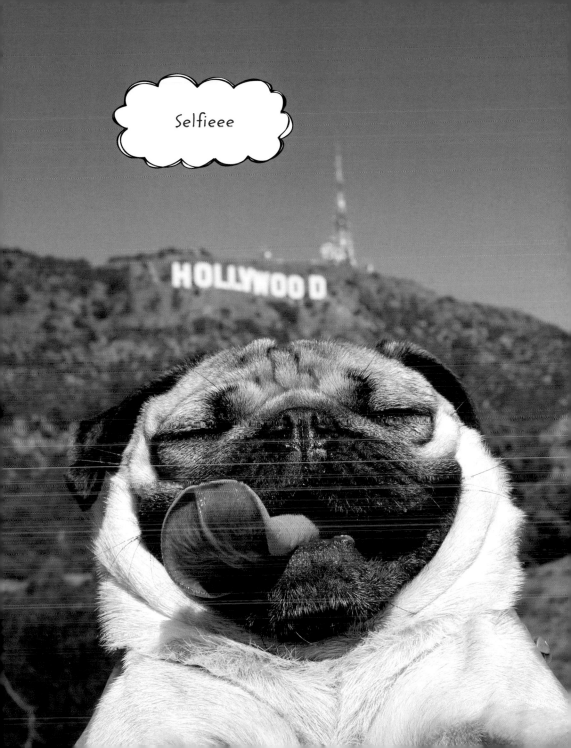

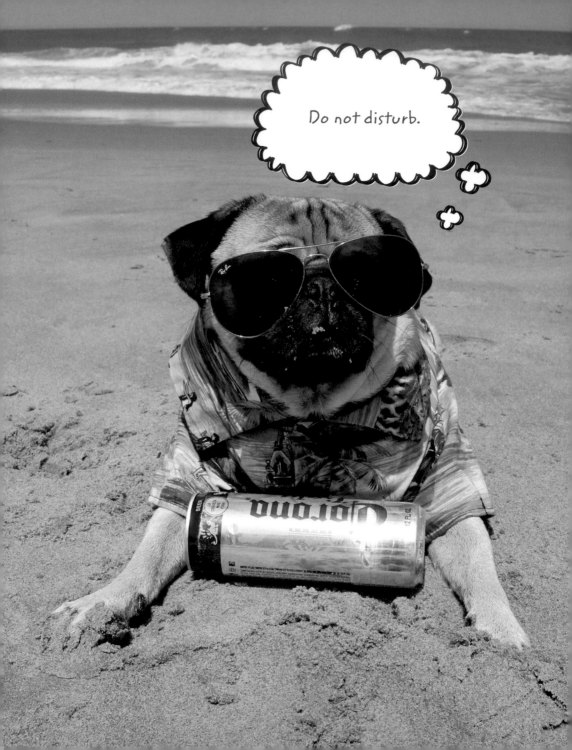

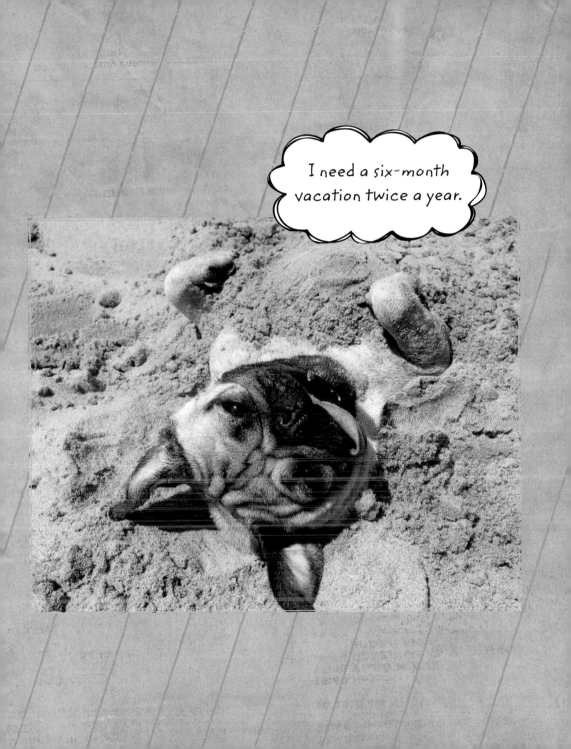

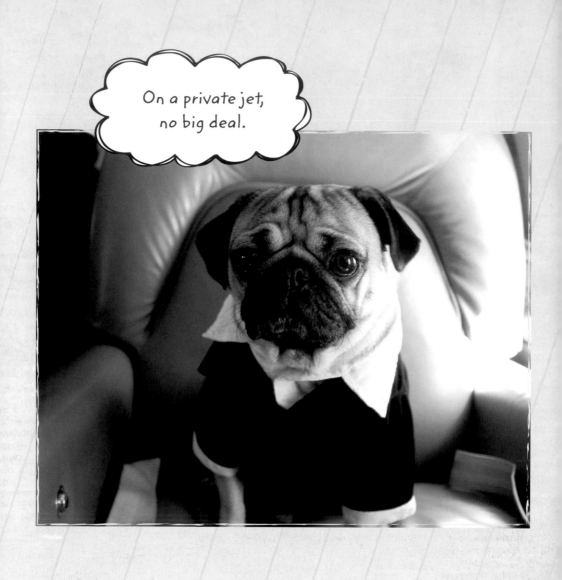

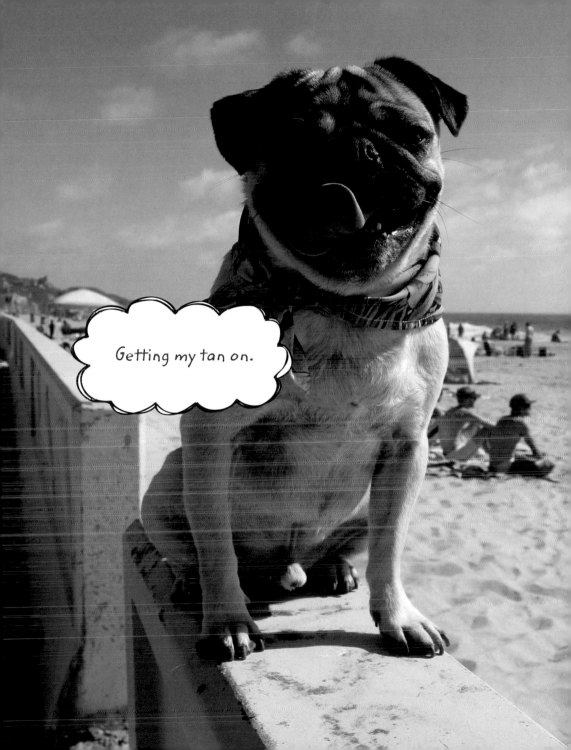

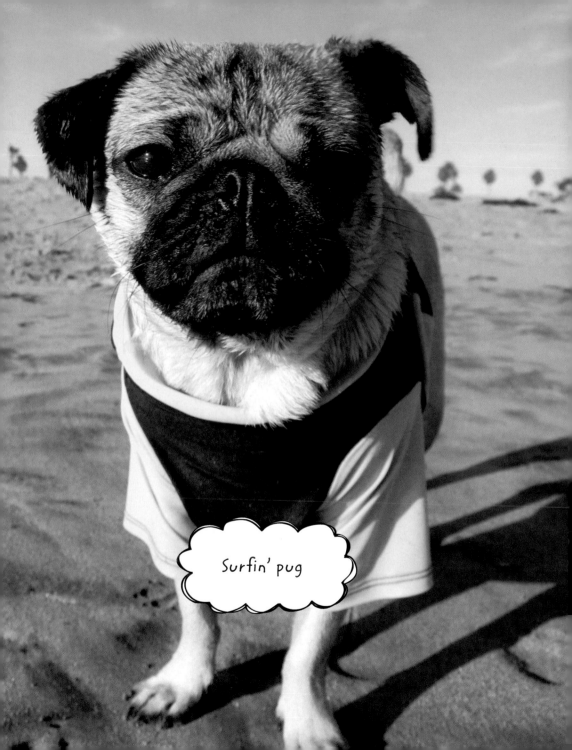

Surfin' pug

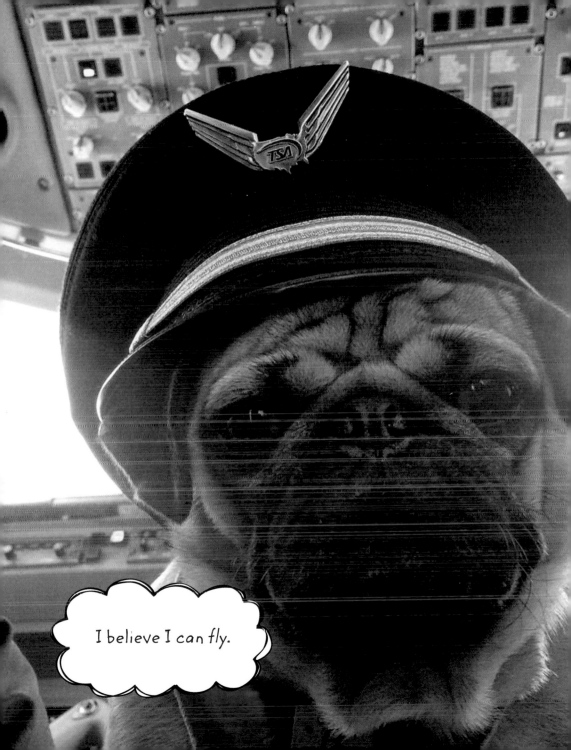

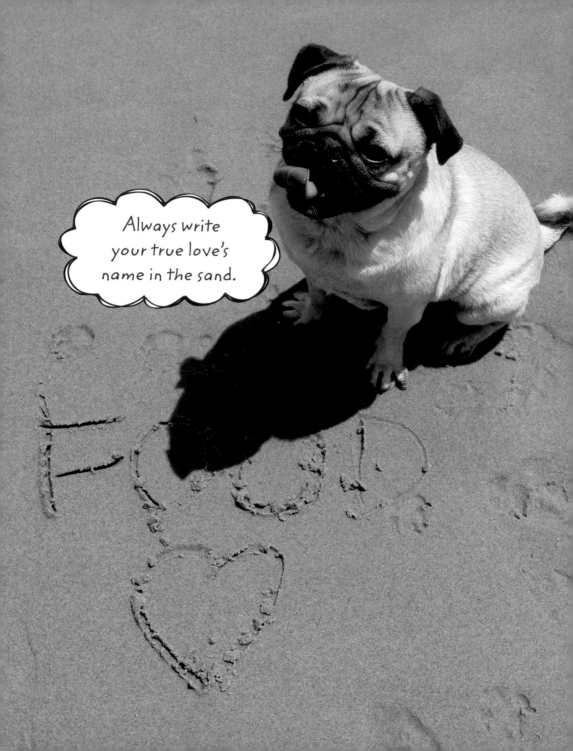

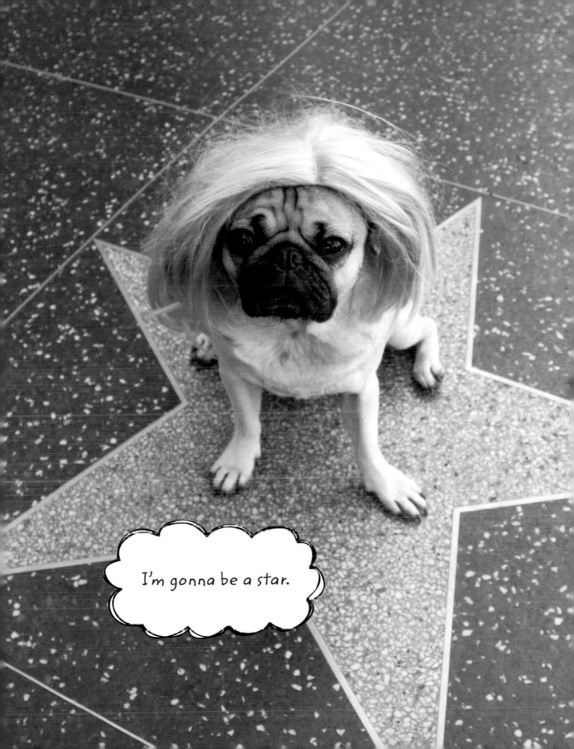

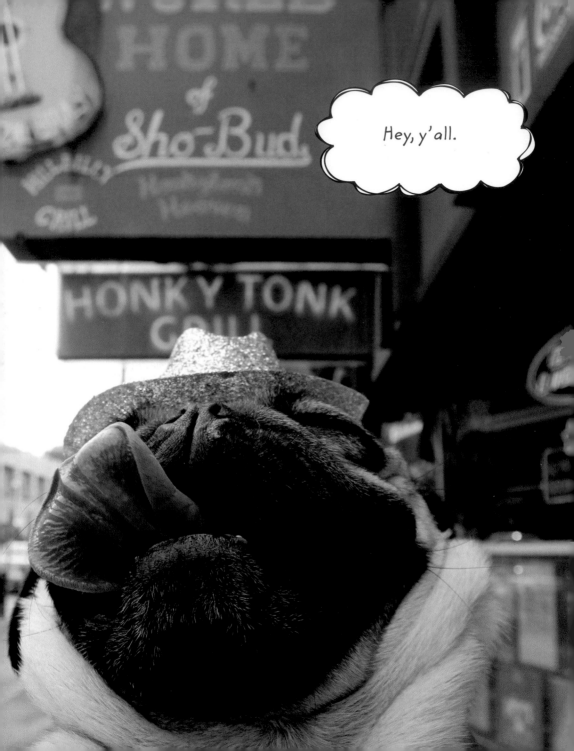

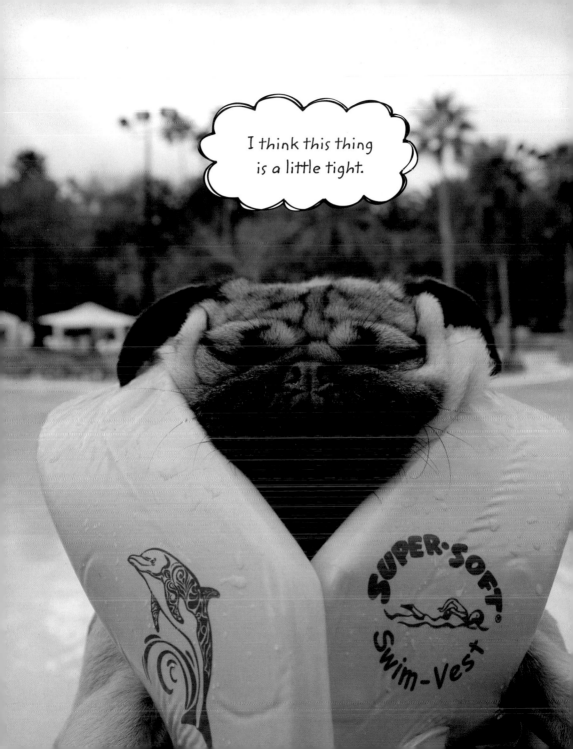

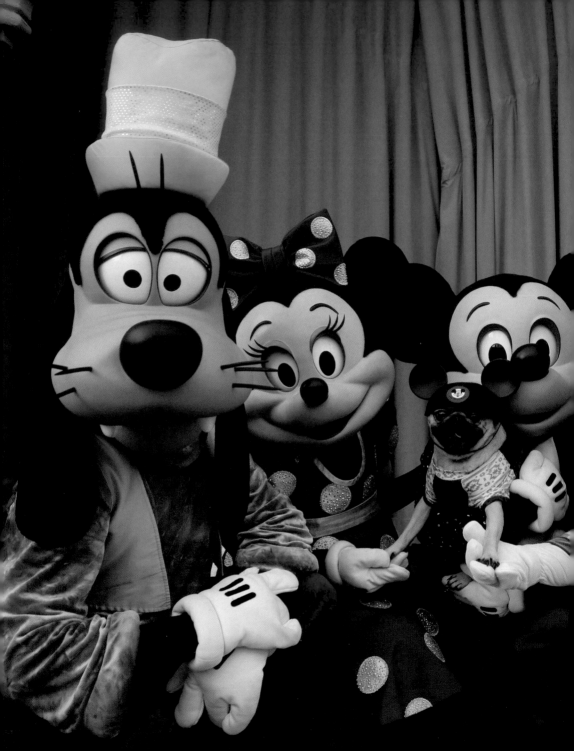

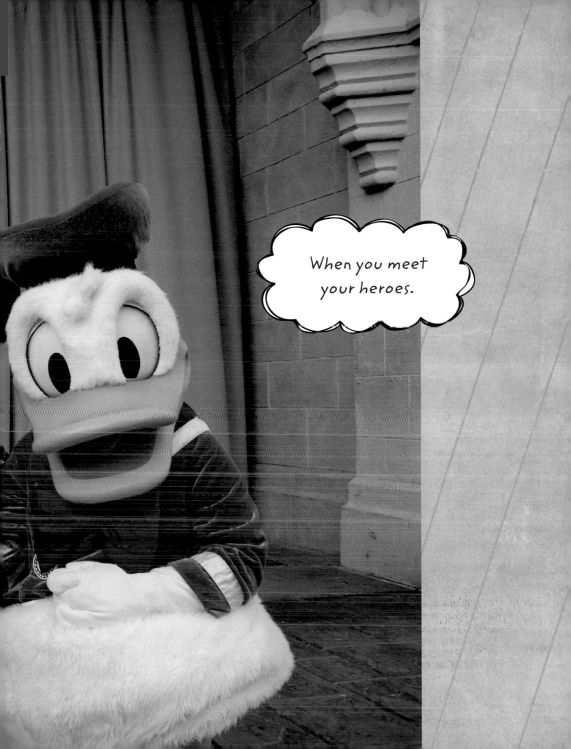

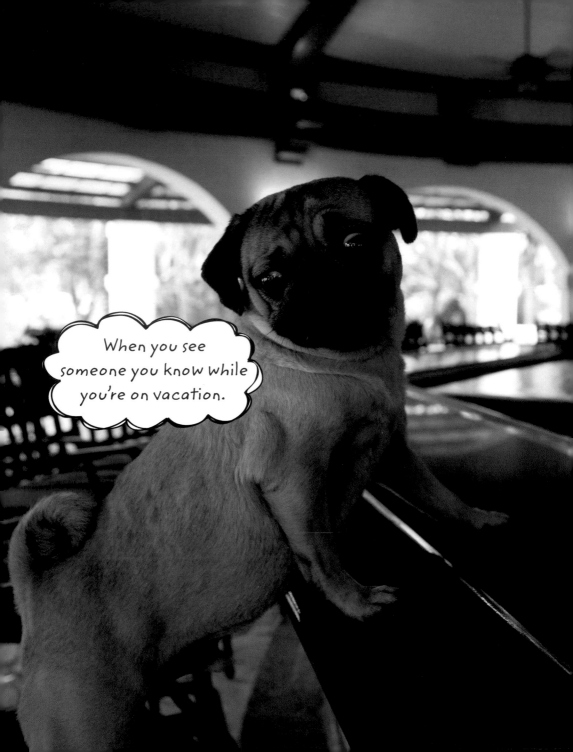

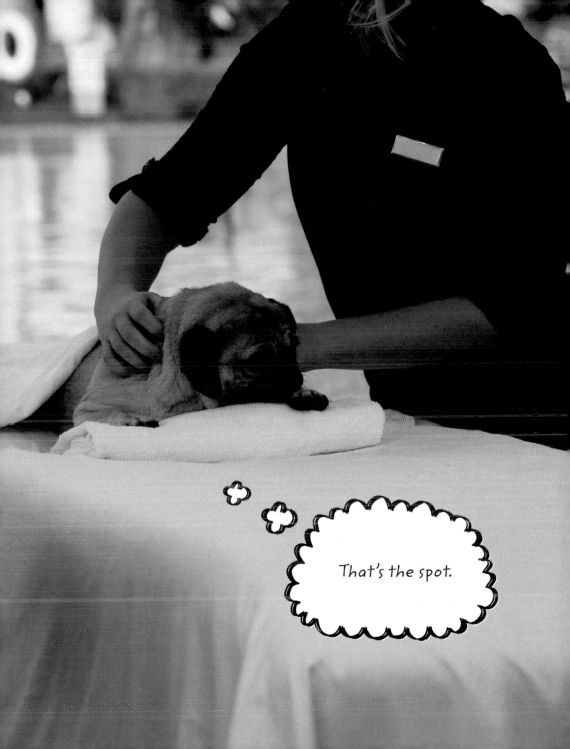

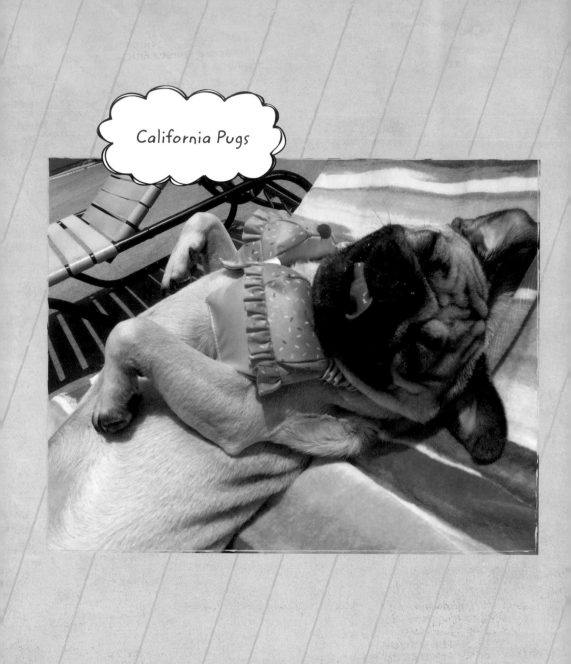

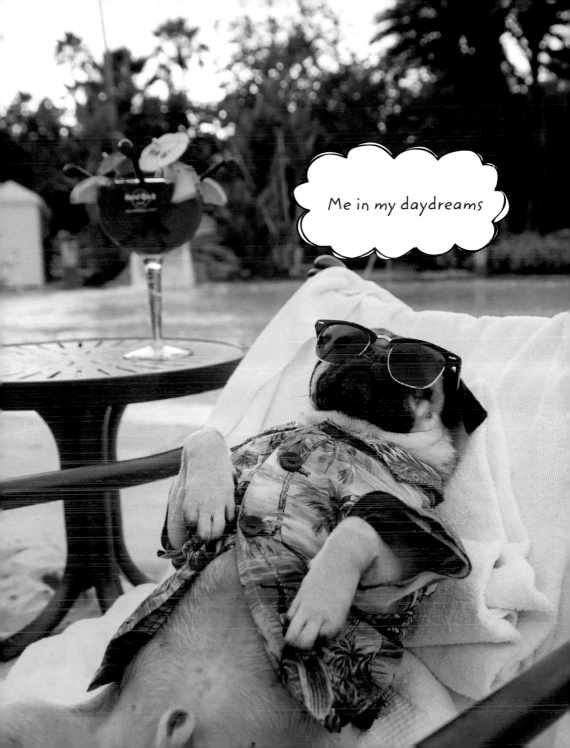

PUG
LIFE

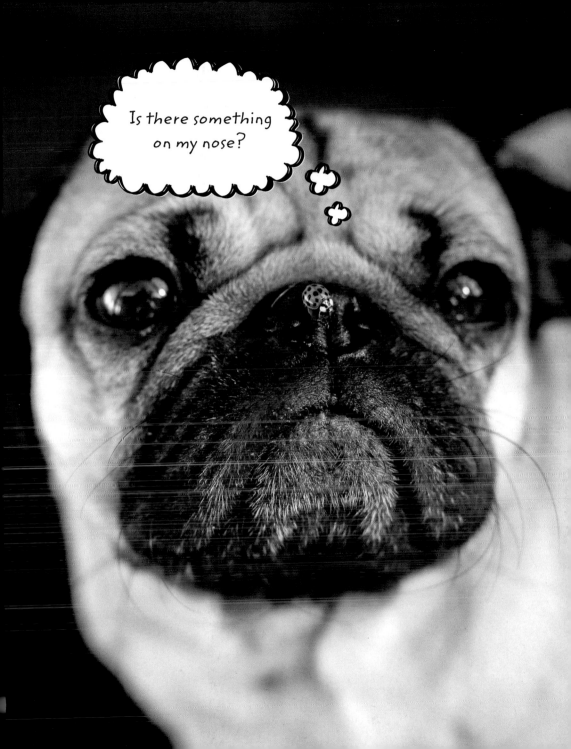

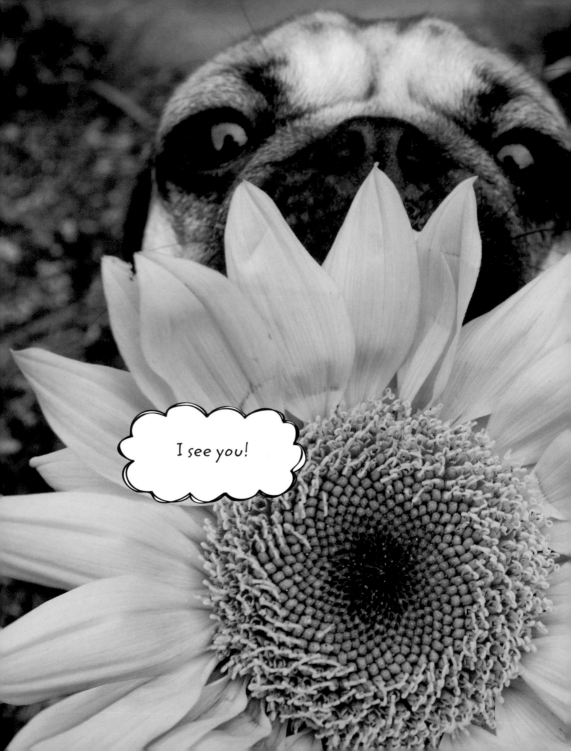

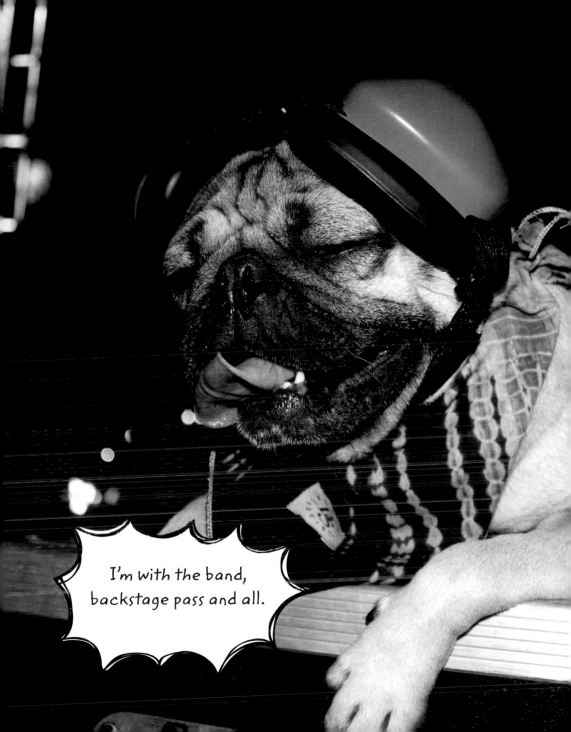

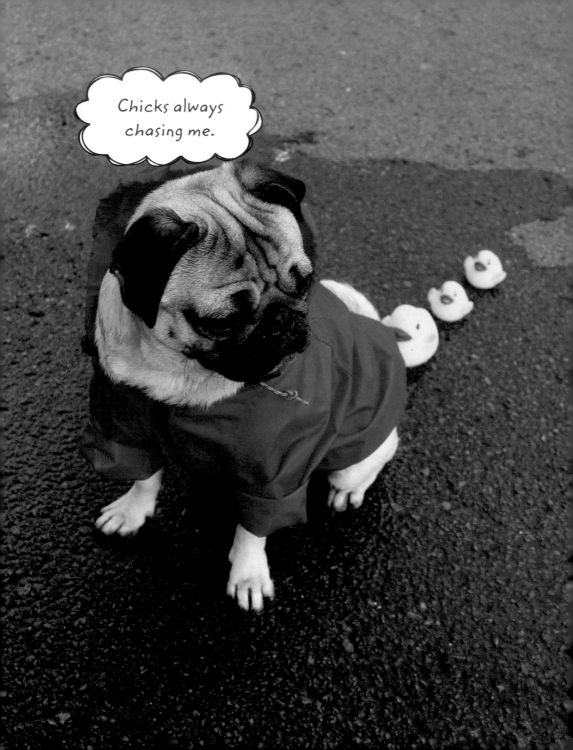

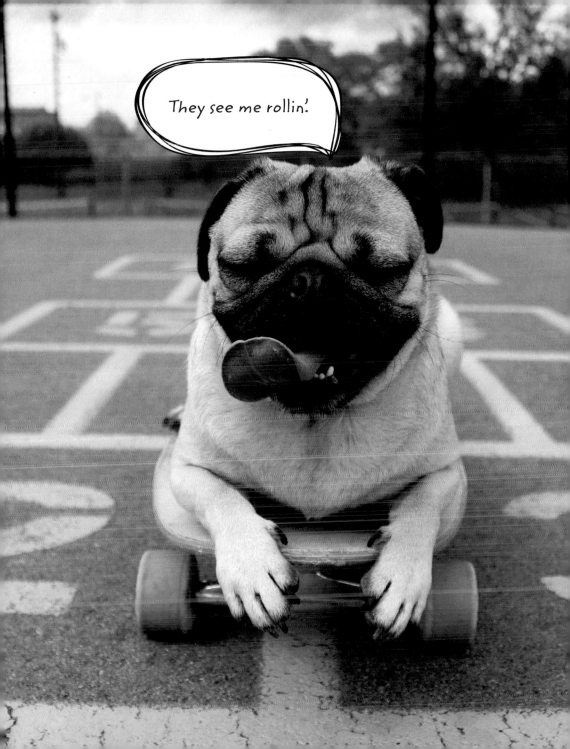

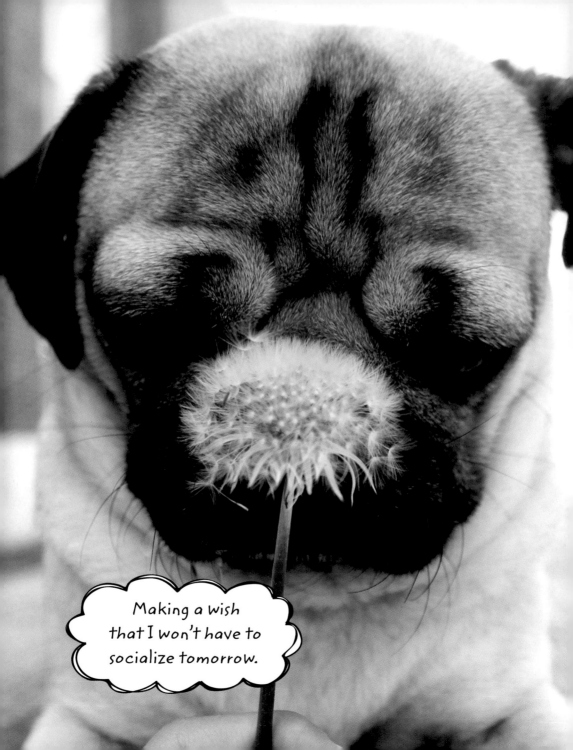

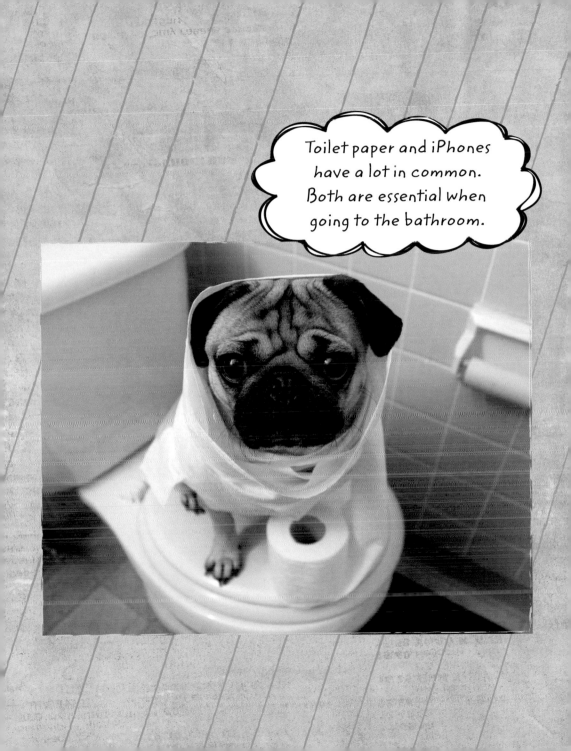

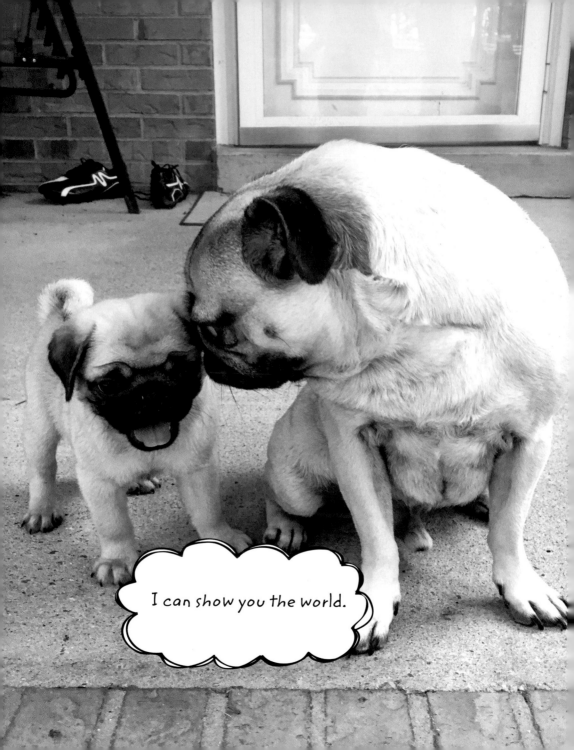

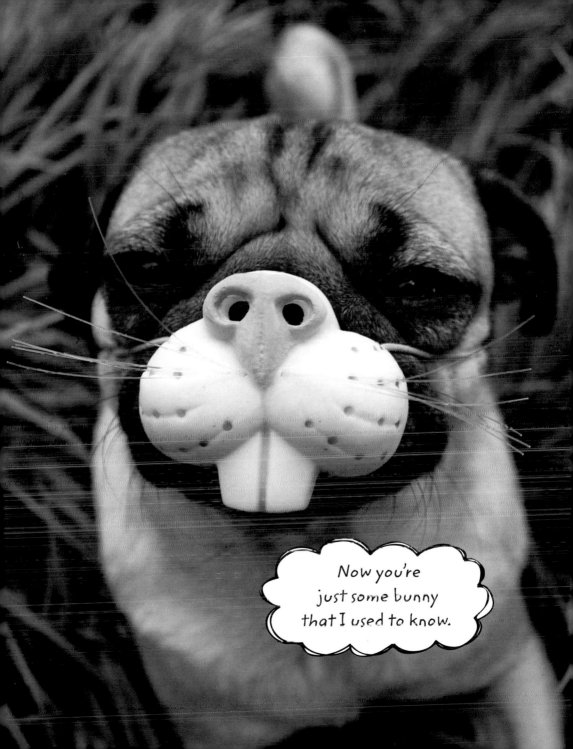

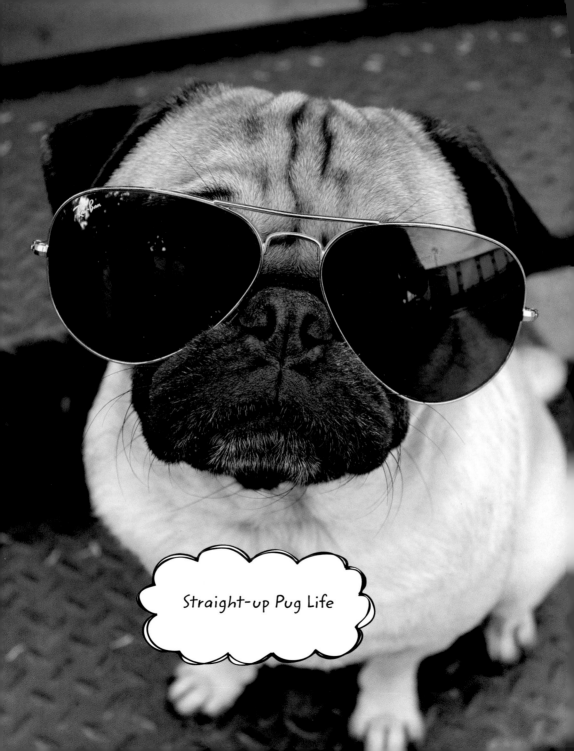

Straight-up Pug Life

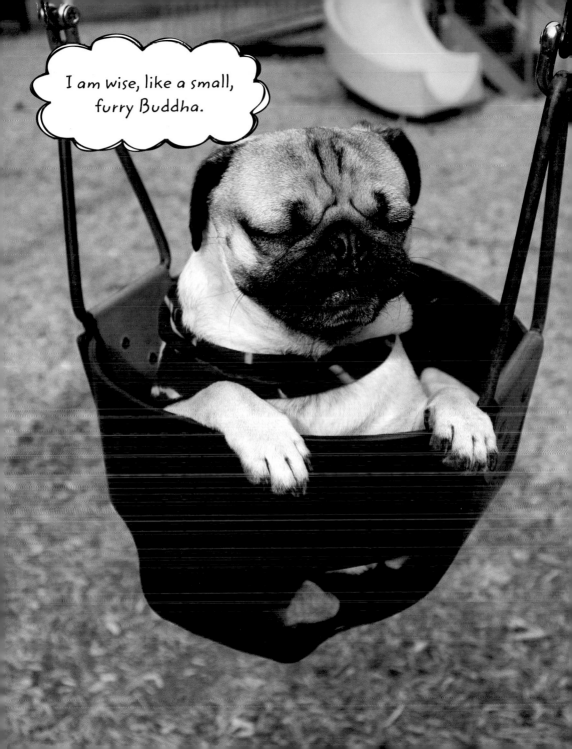

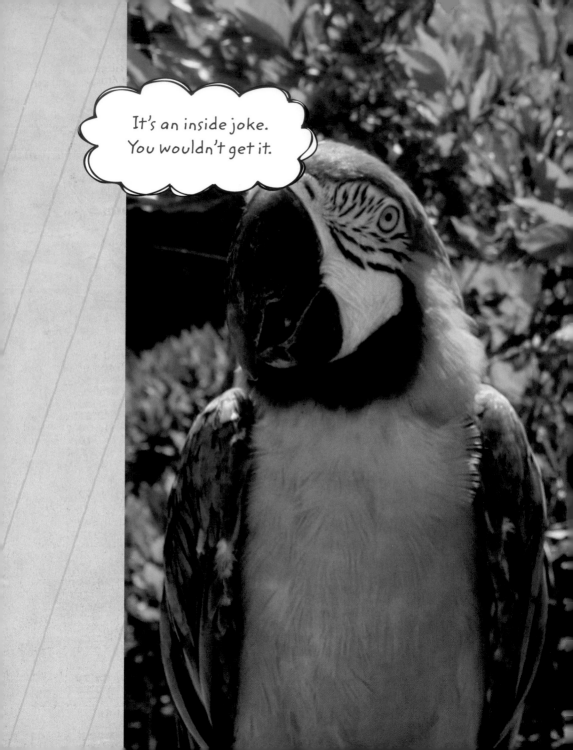

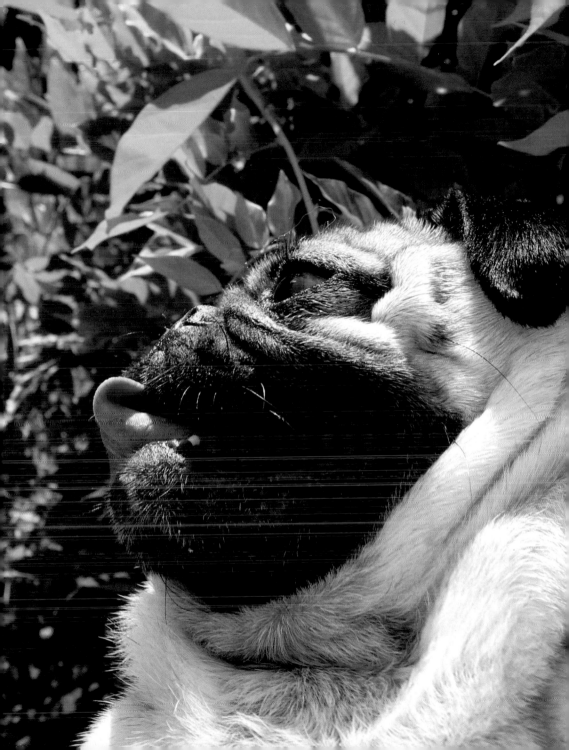

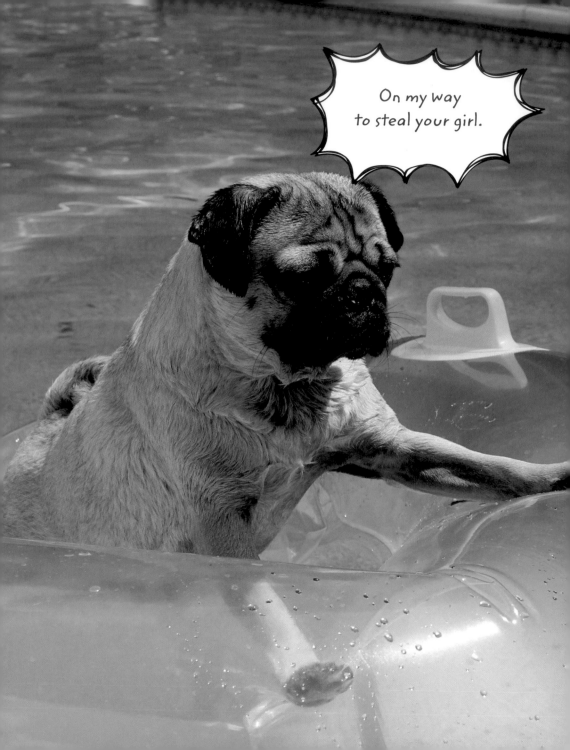

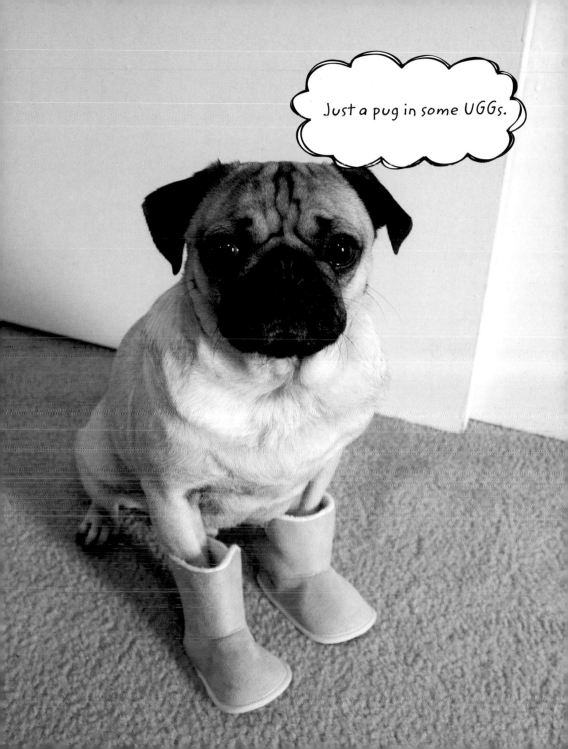

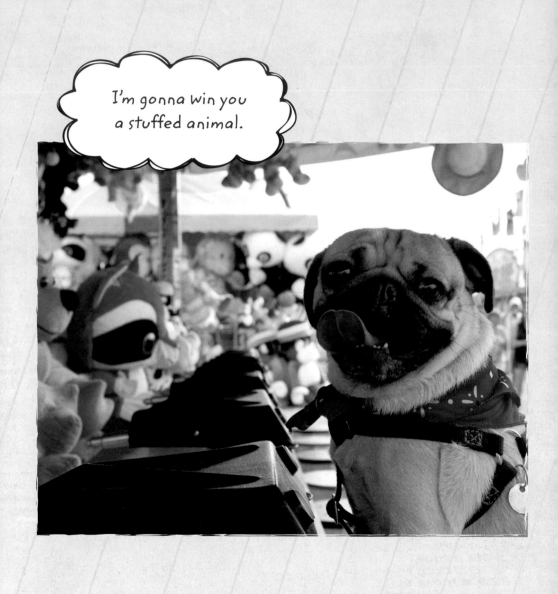

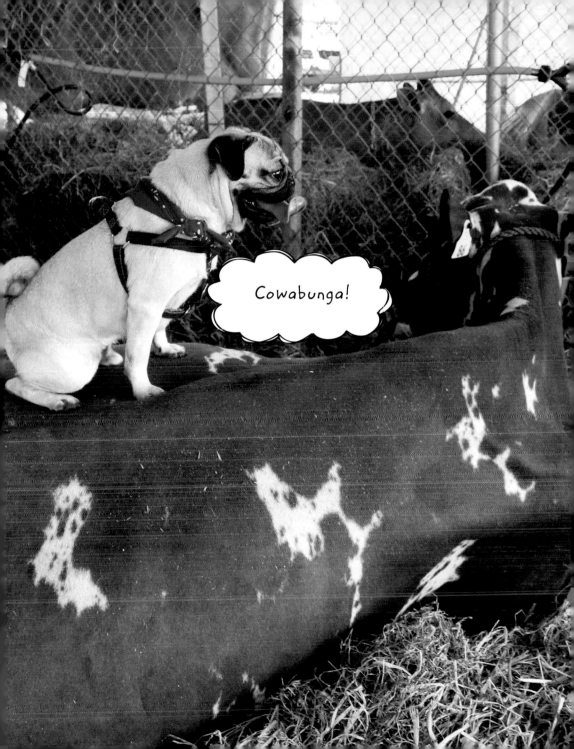

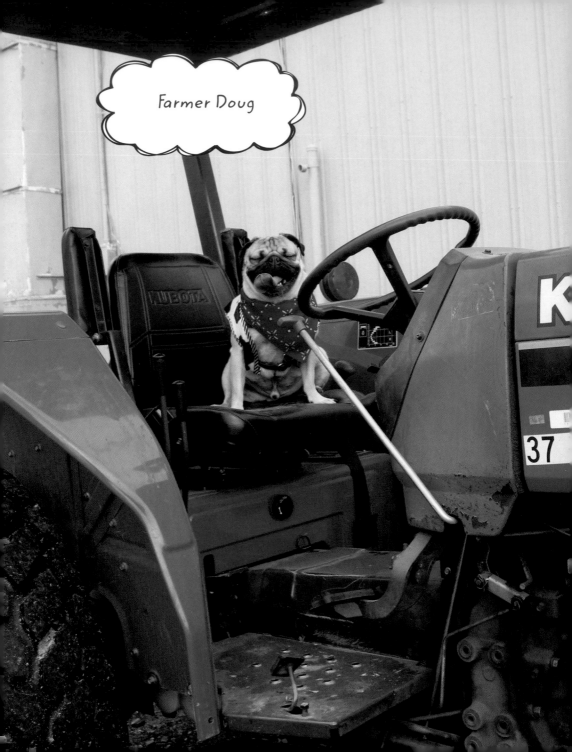

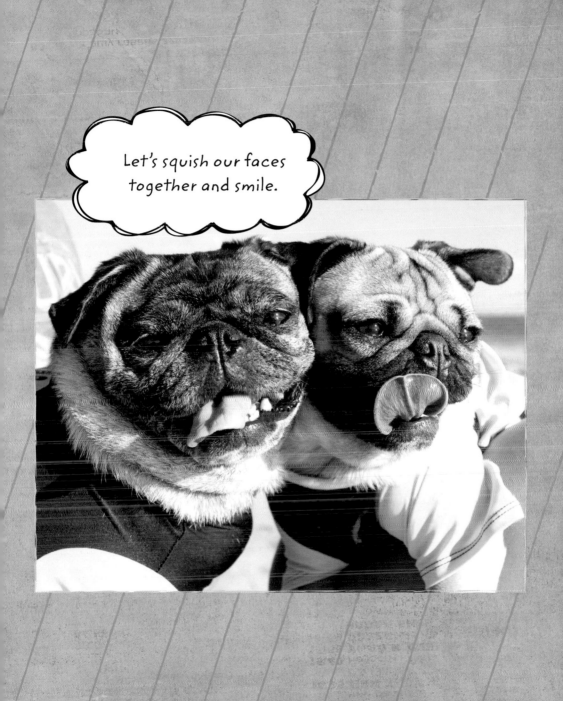

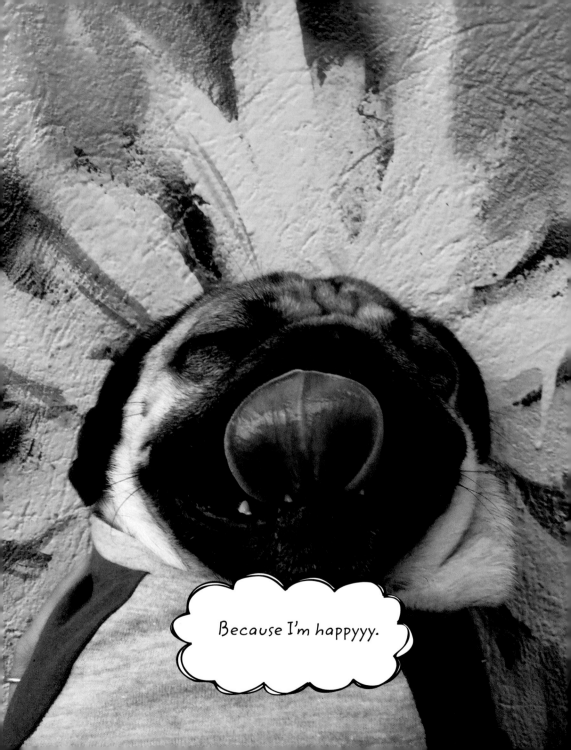

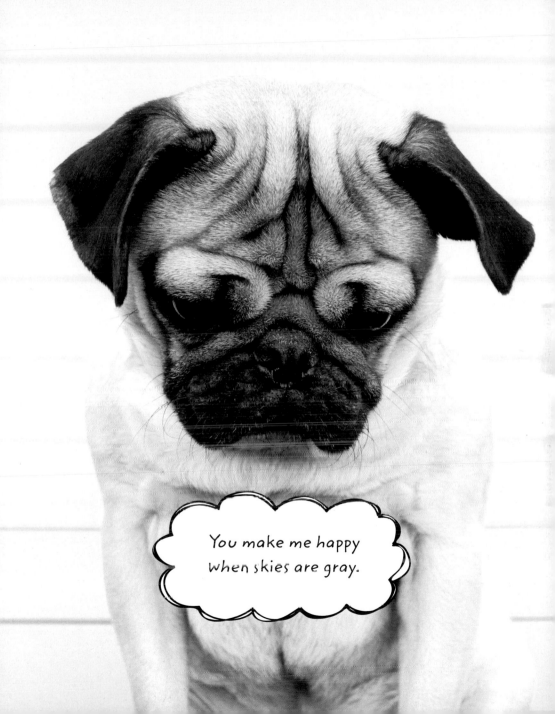

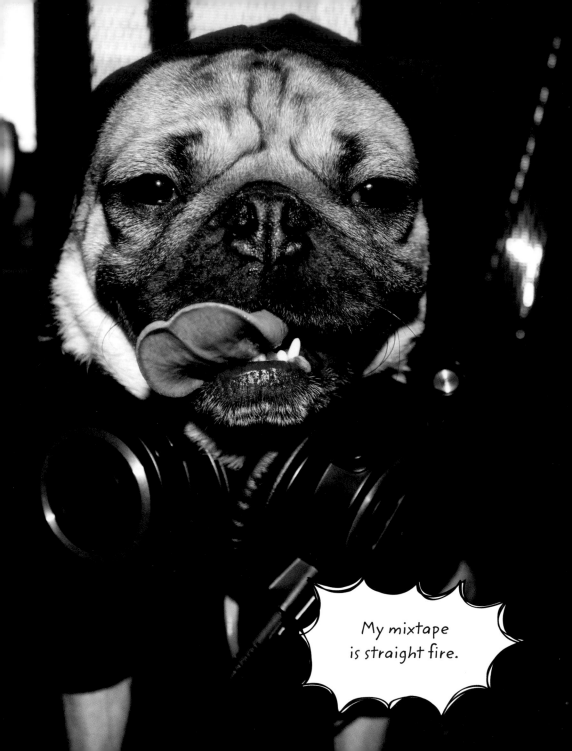

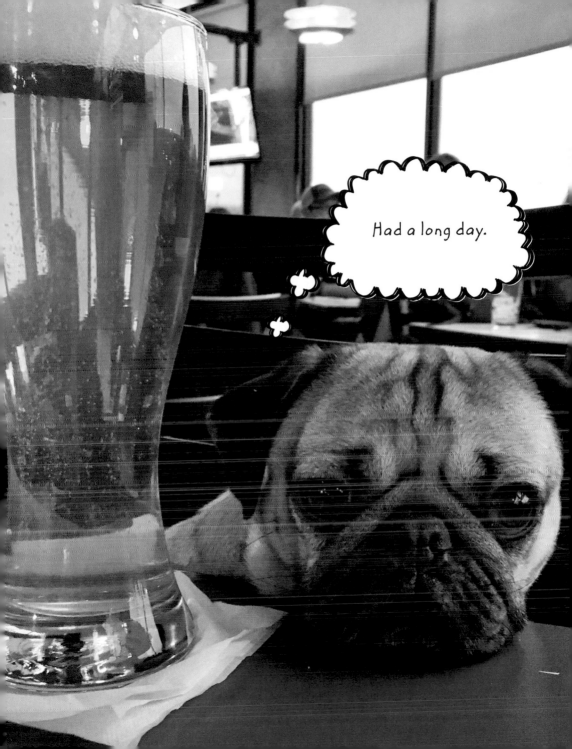

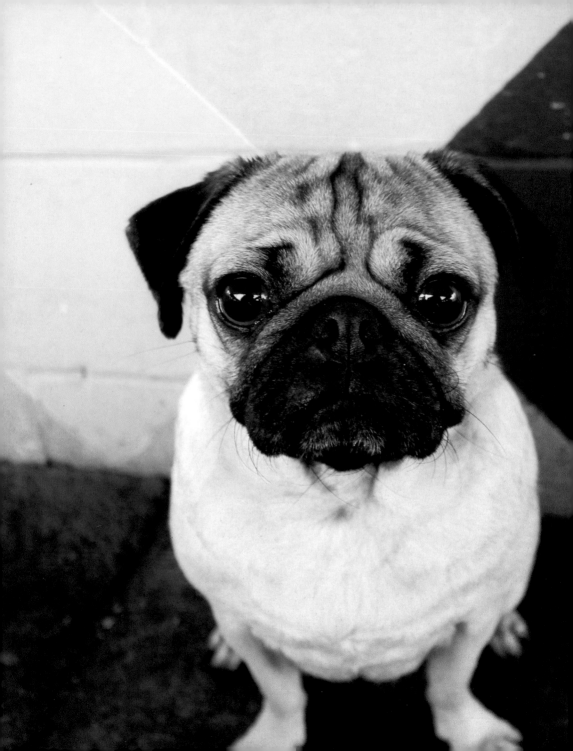

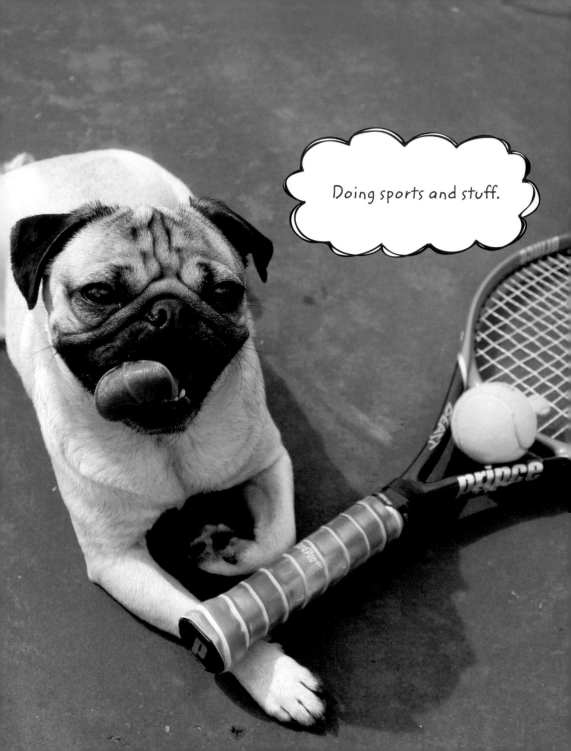

ALL
DRESSED
UP

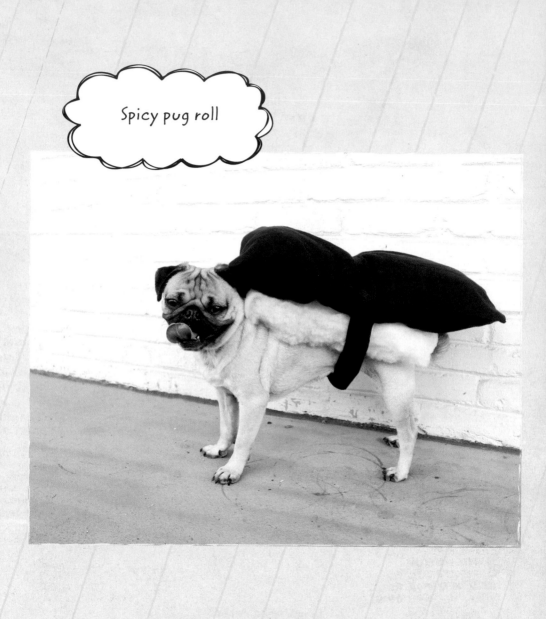

Spicy pug roll

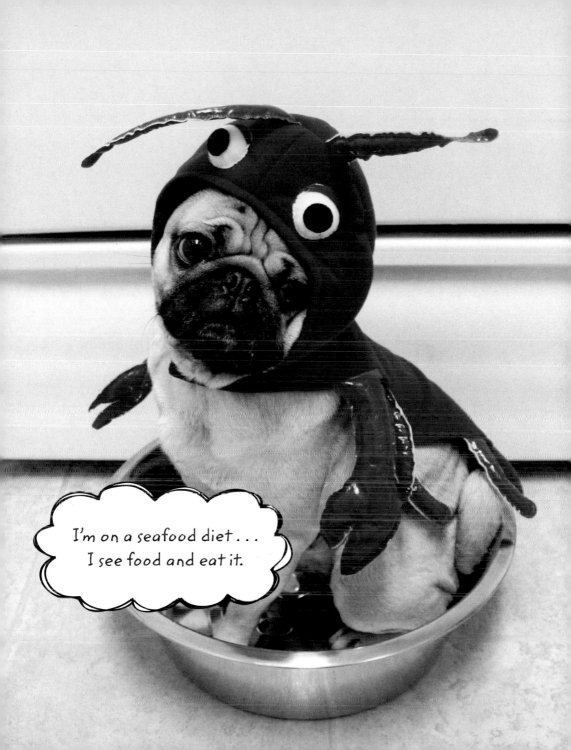

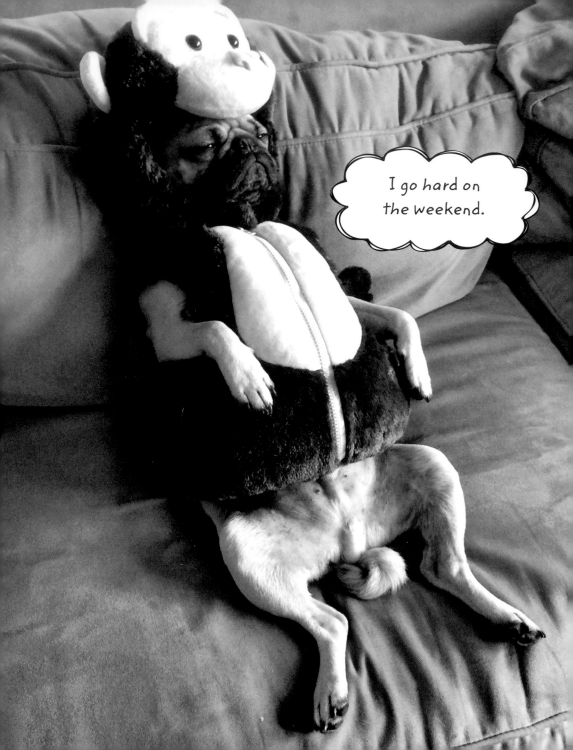

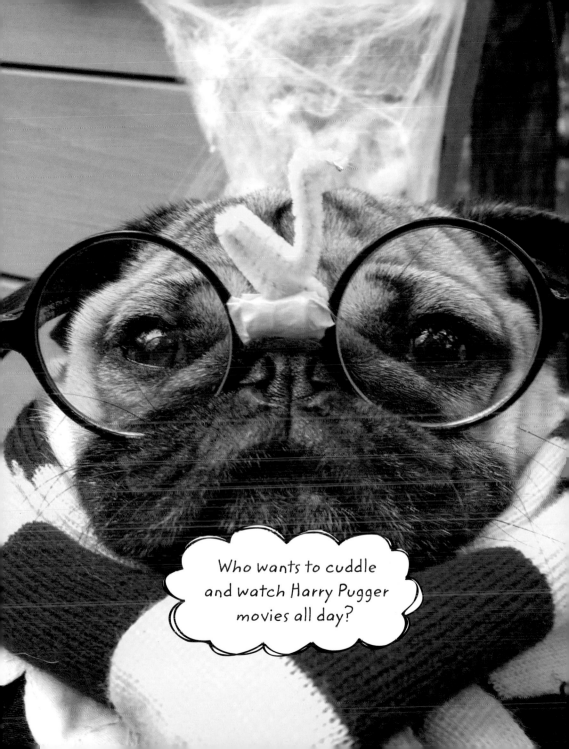

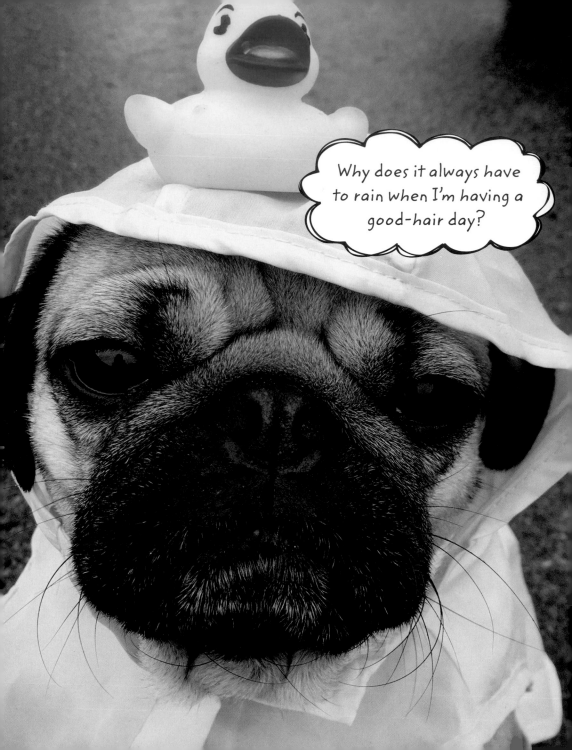

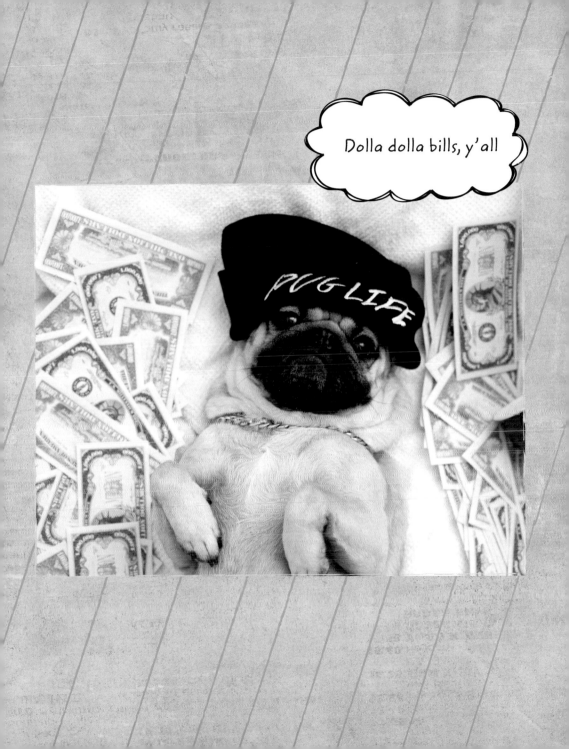

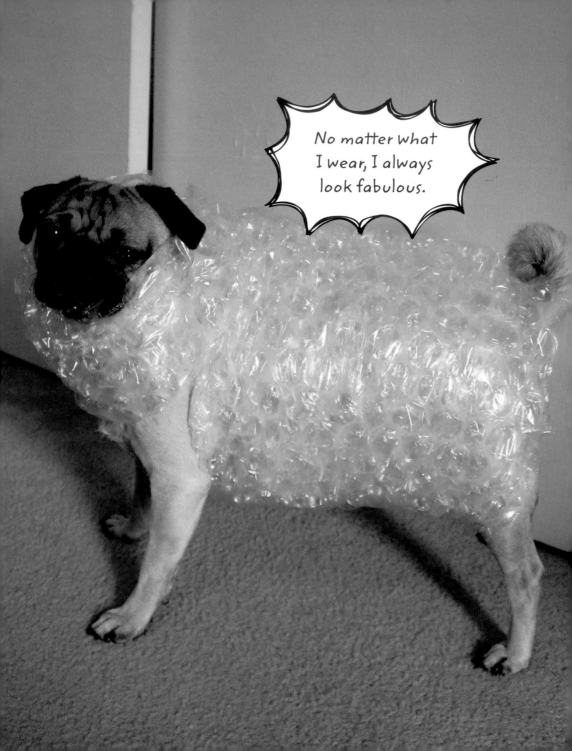

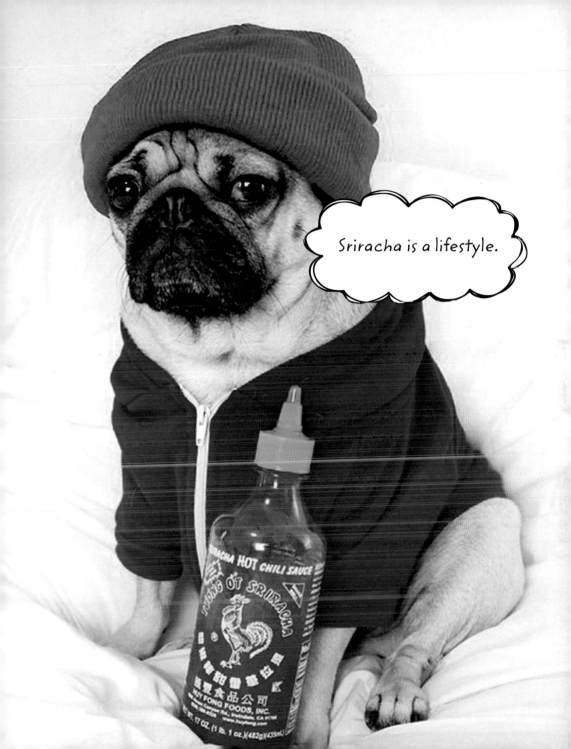

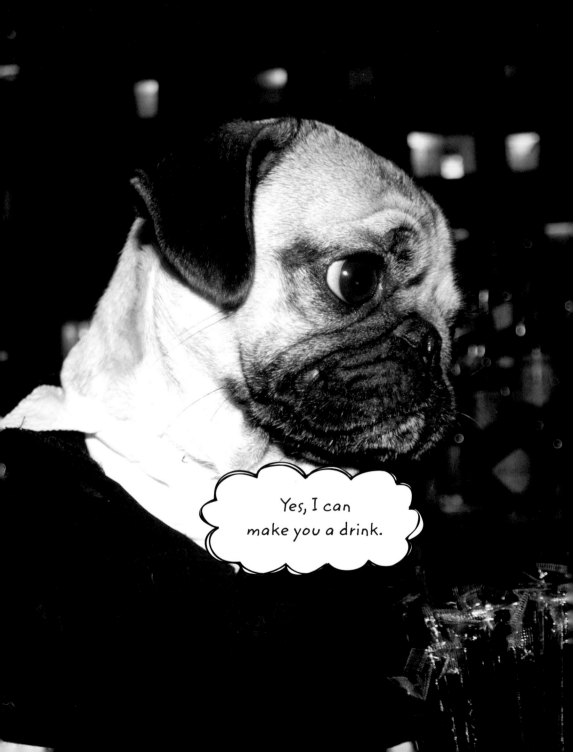

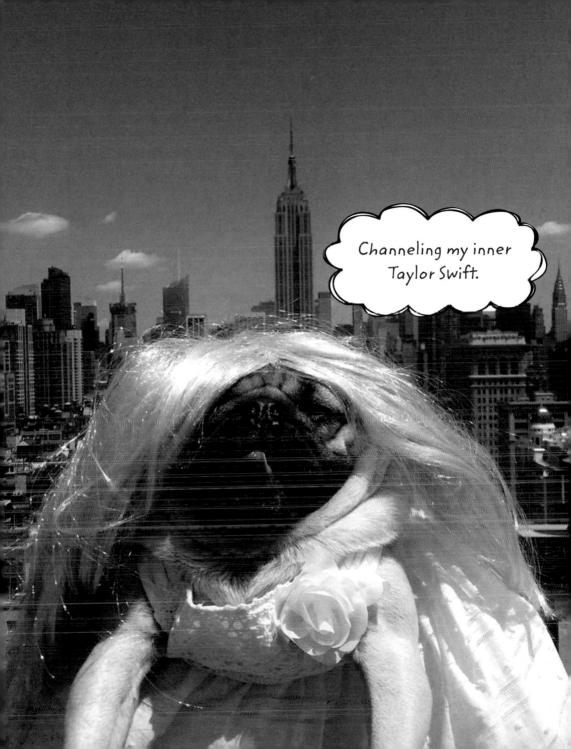

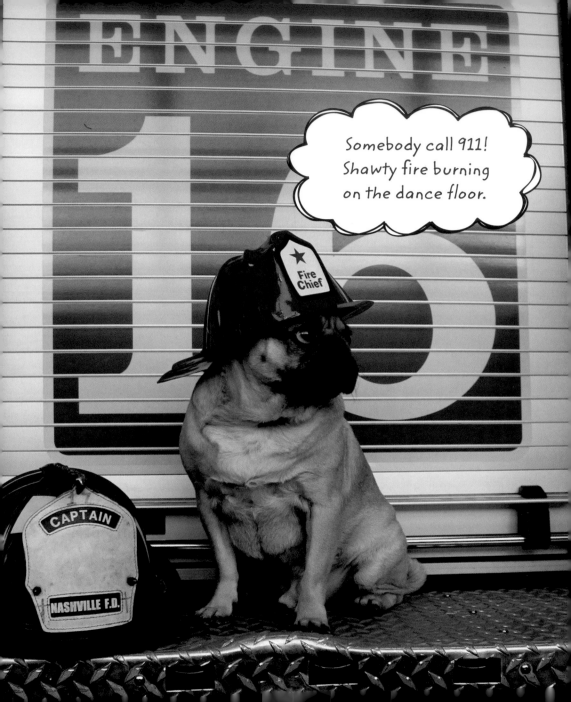

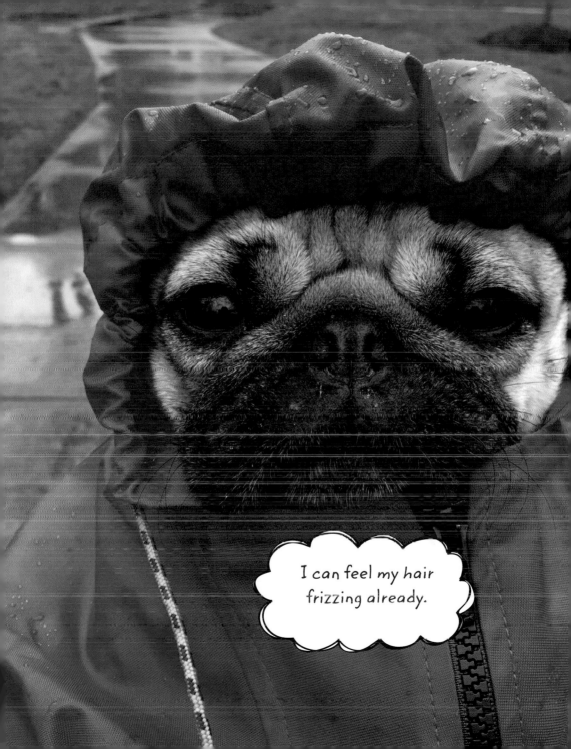

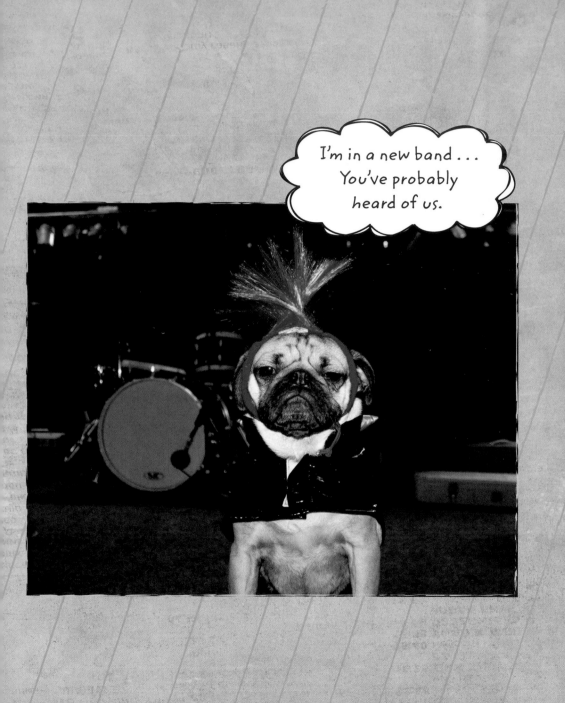

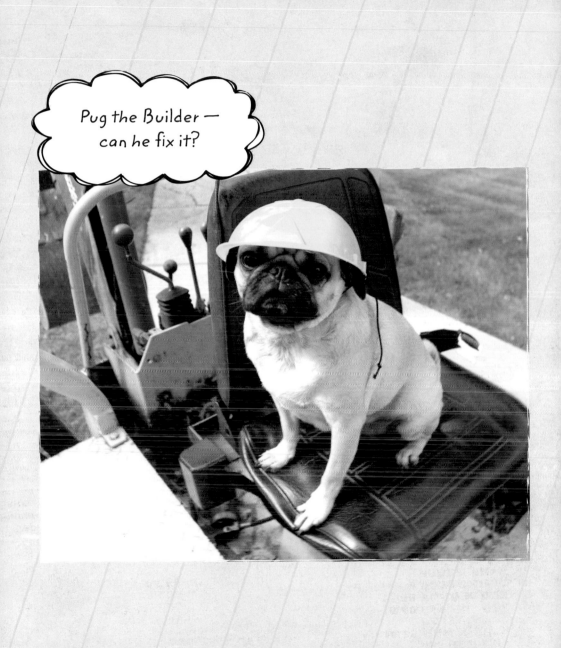

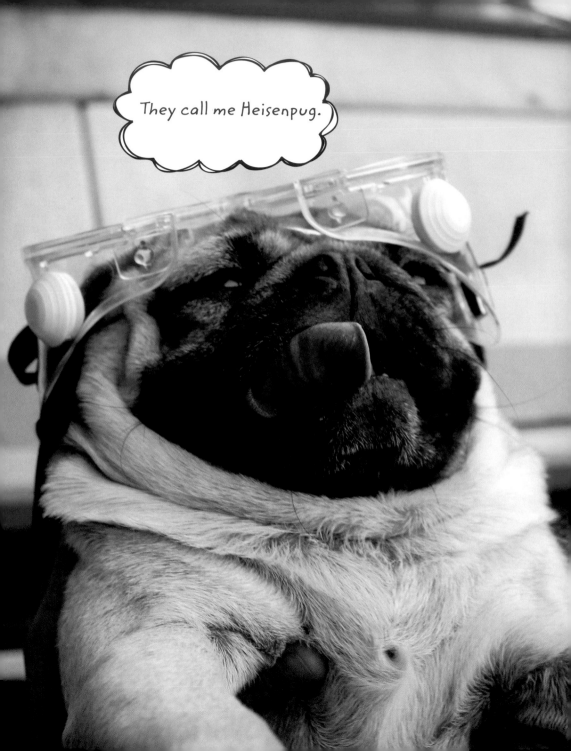

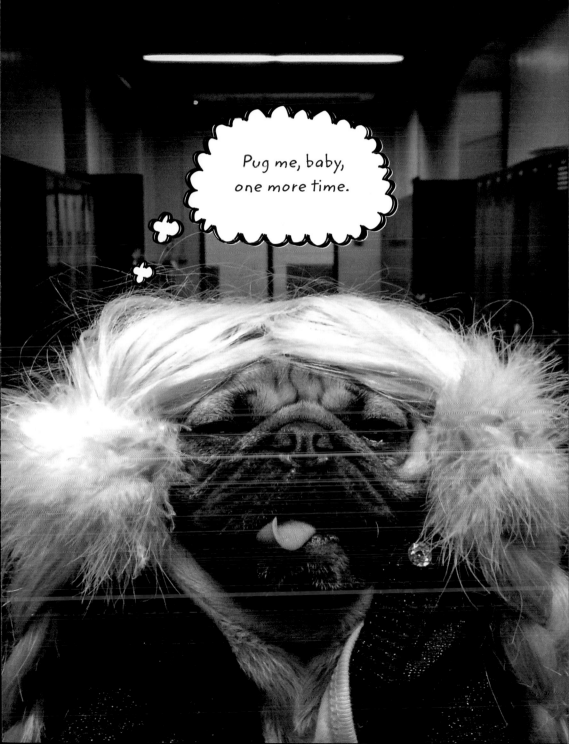

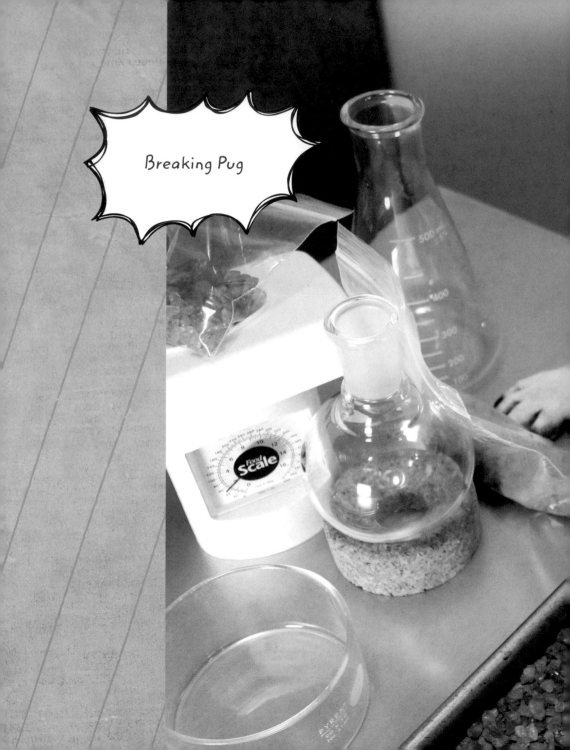

Breaking Pug

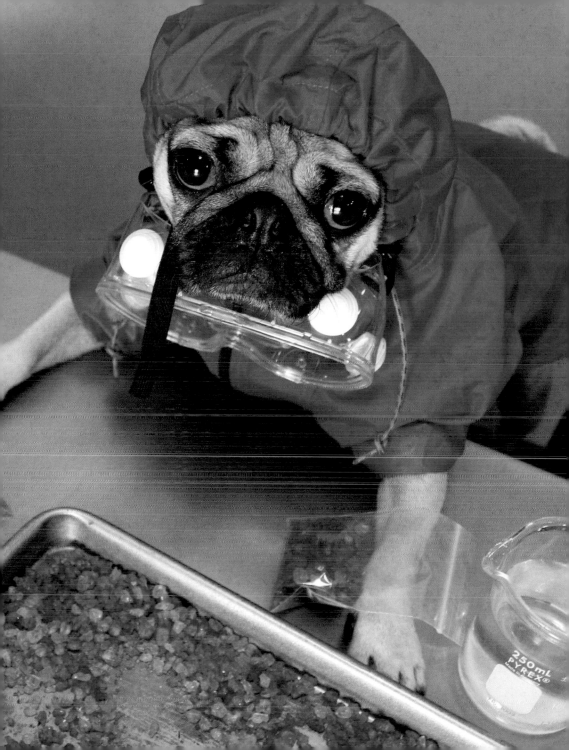

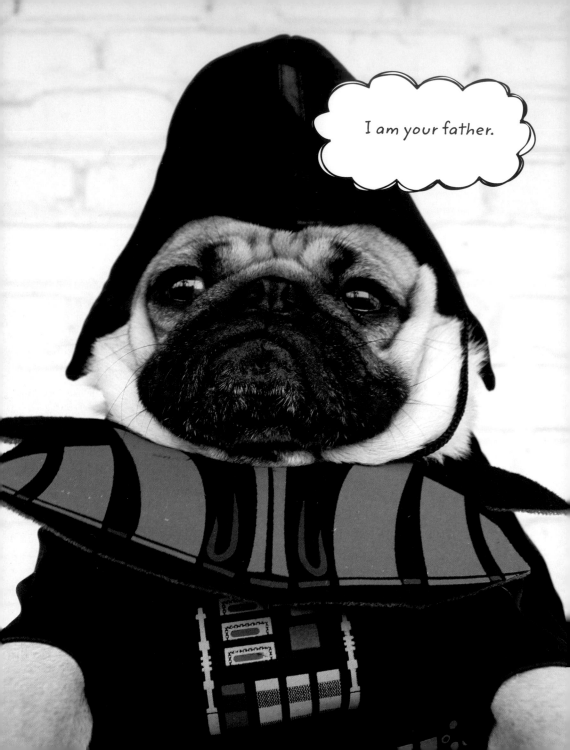

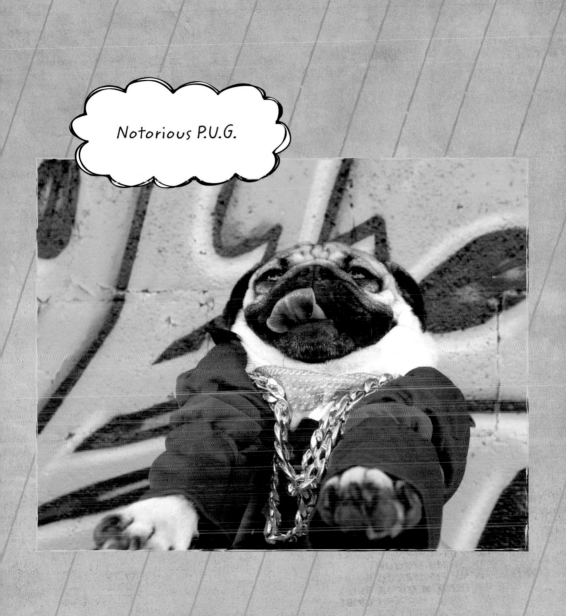

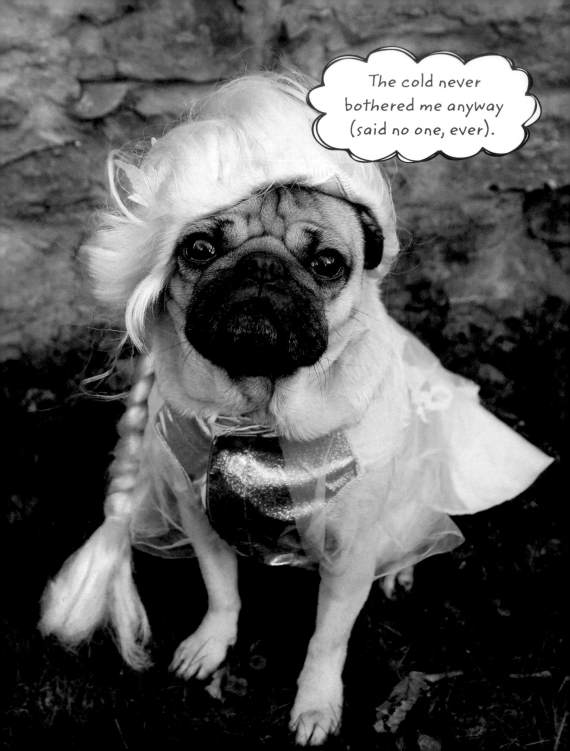

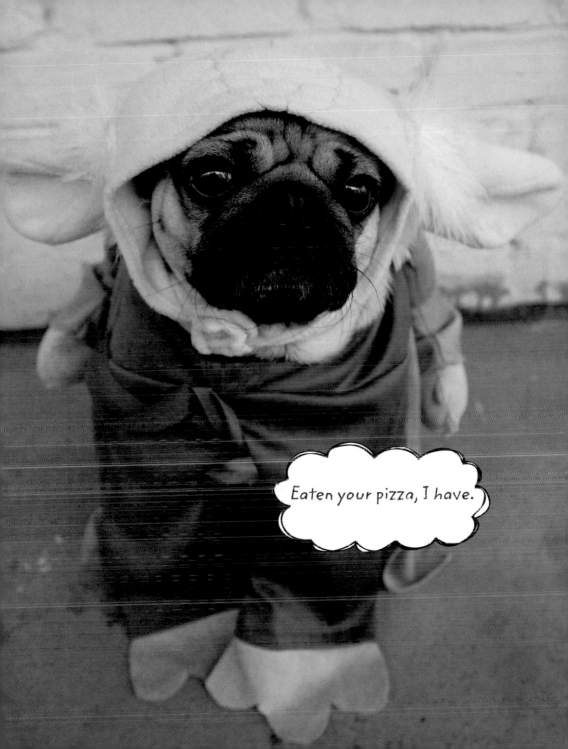

Eaten your pizza, I have.

FOOD:
MY REASON
FOR LIVING

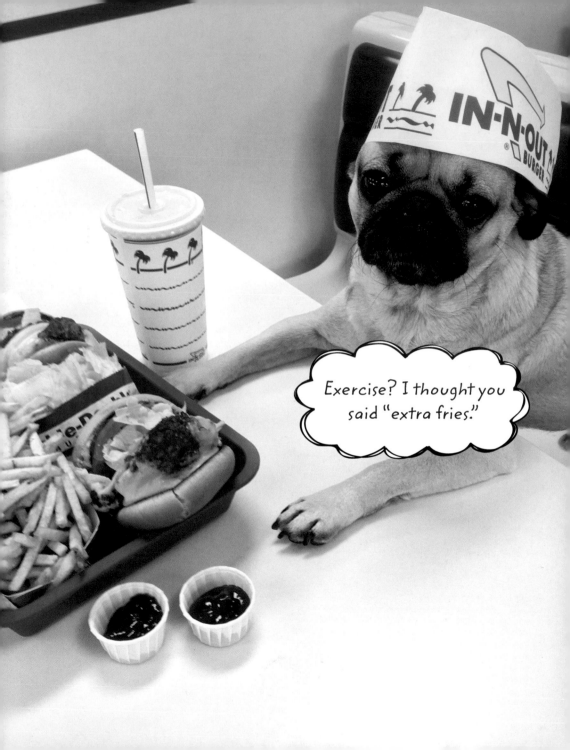

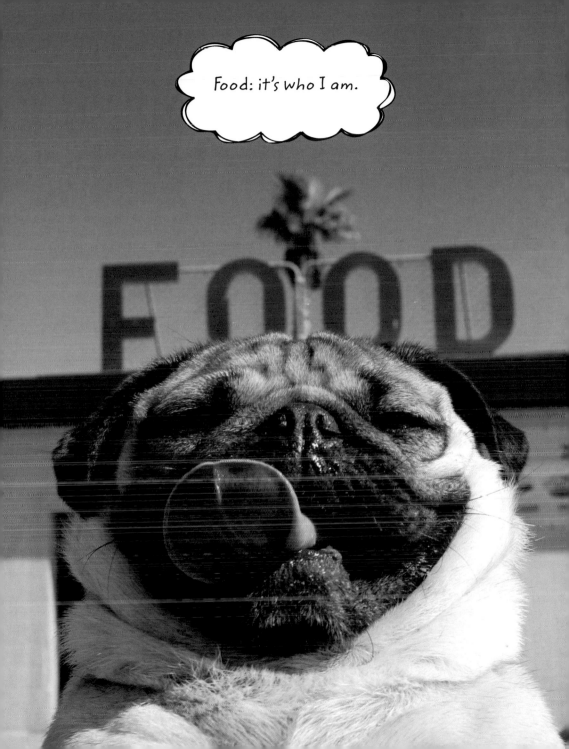

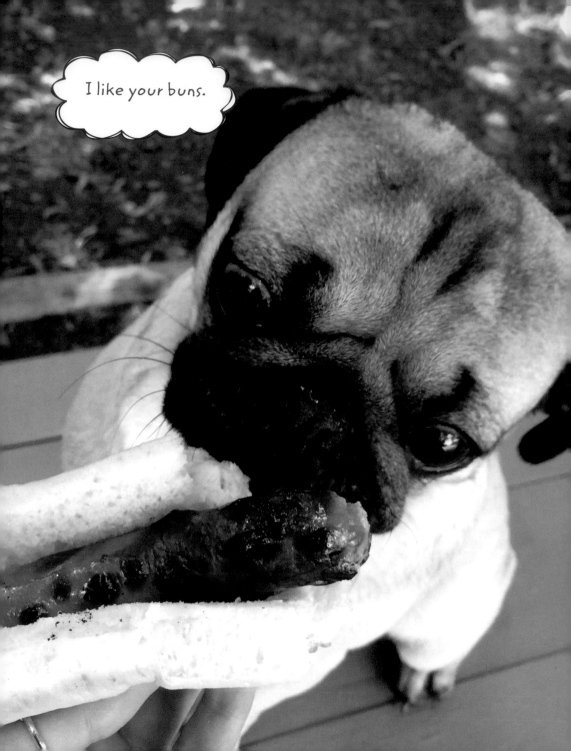

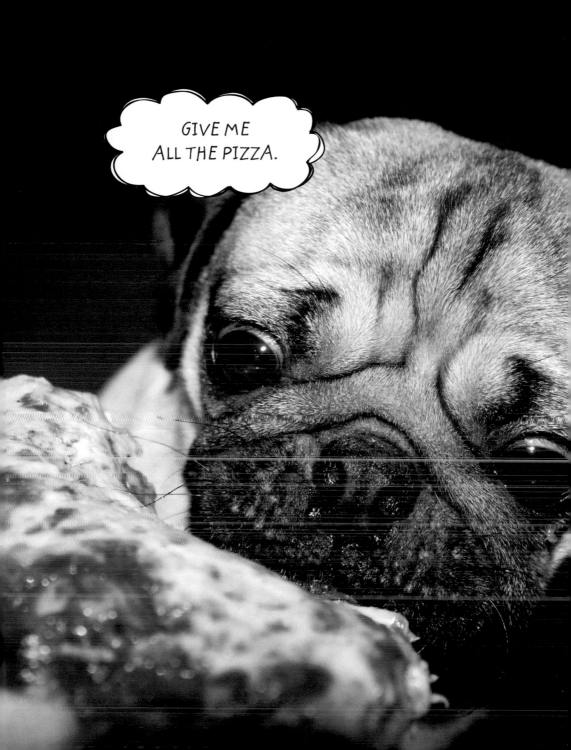

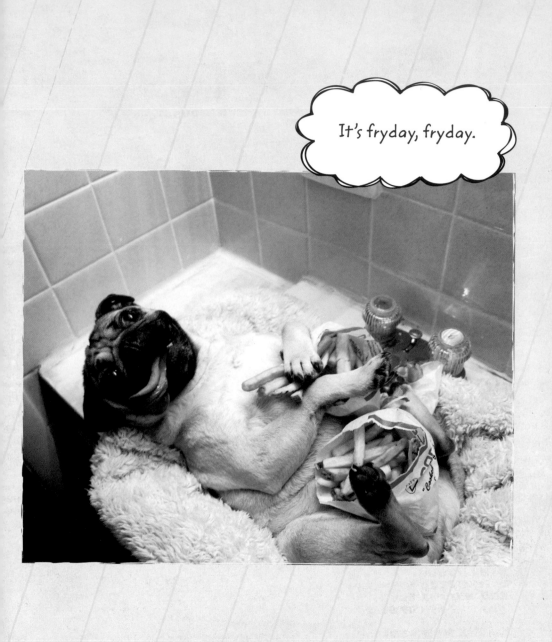

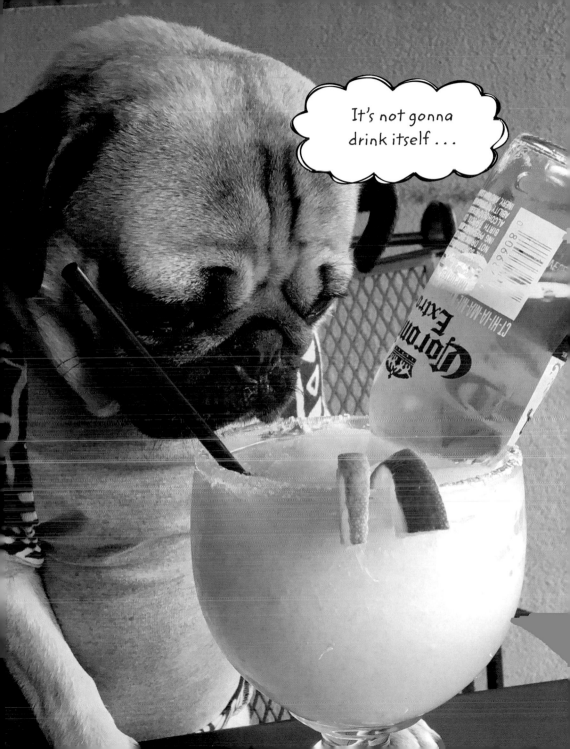

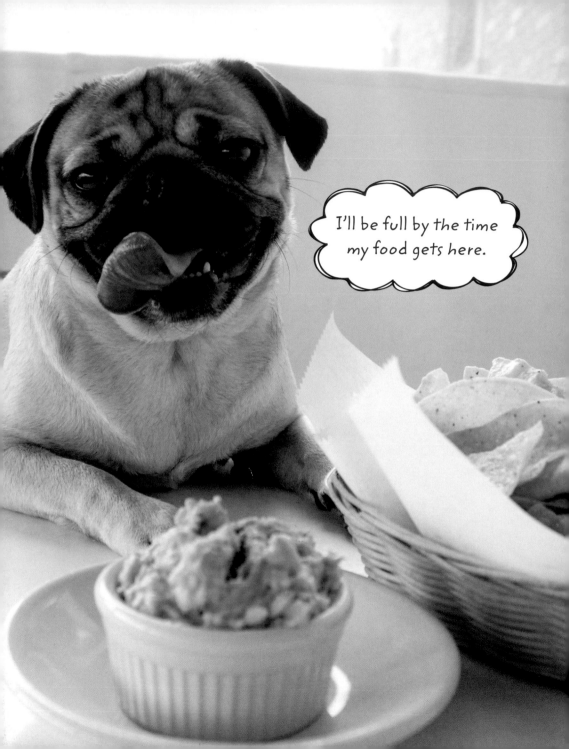

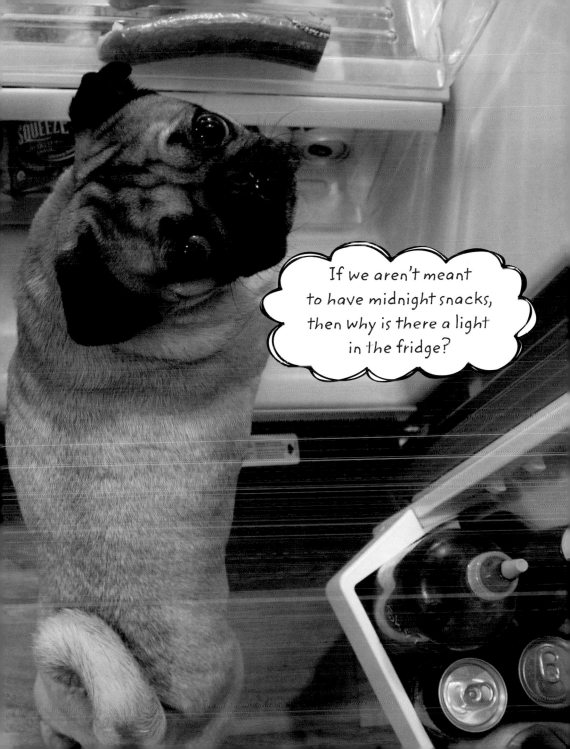

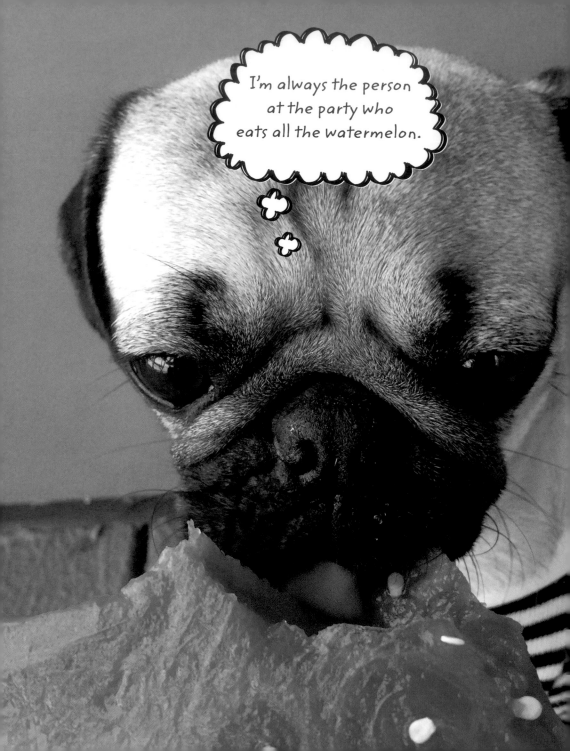

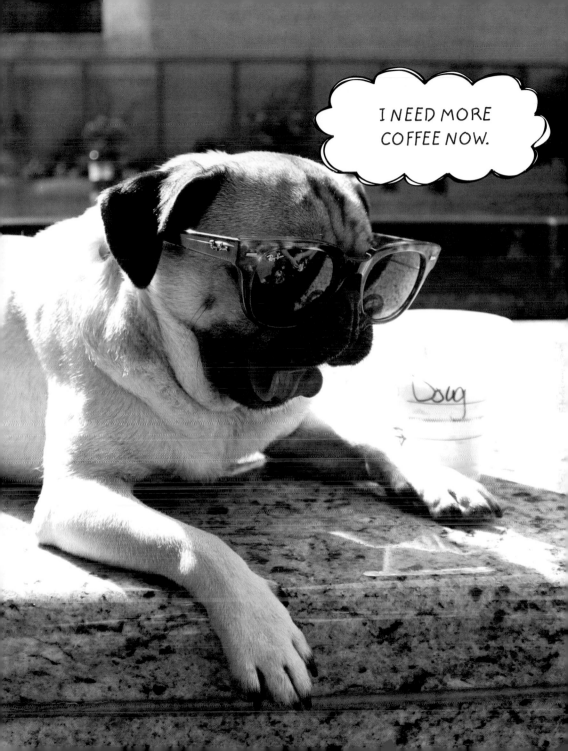

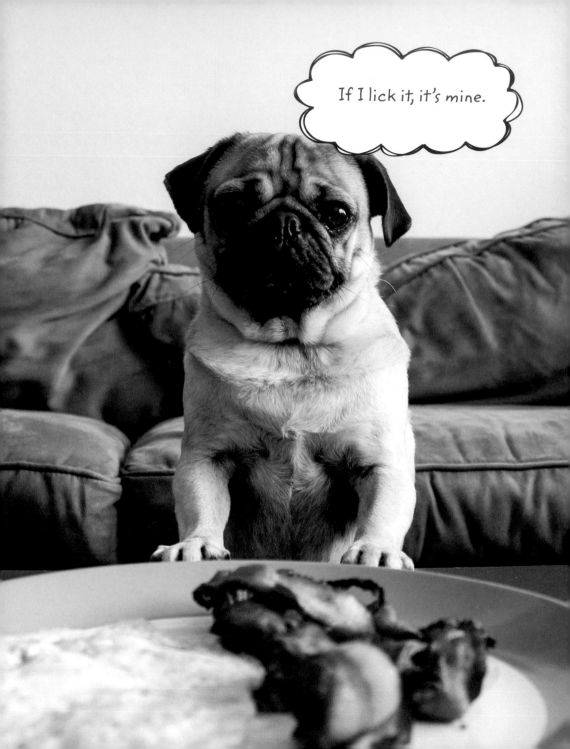

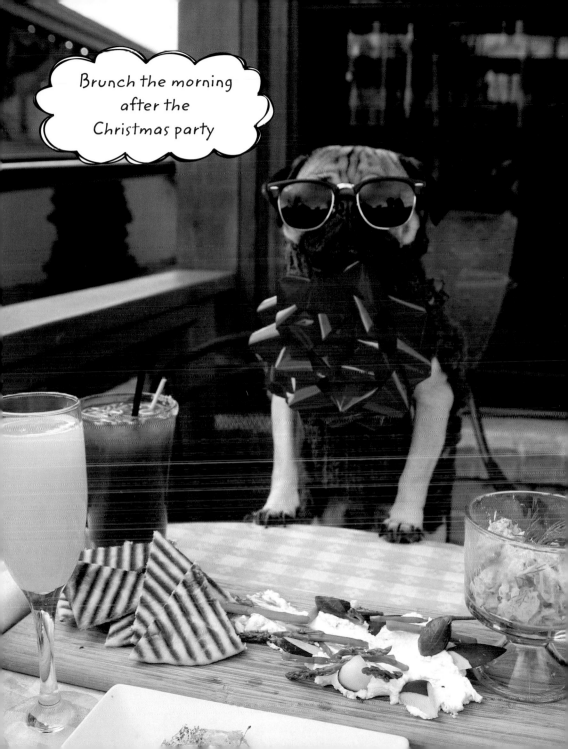

Brunch the morning
after the
Christmas party

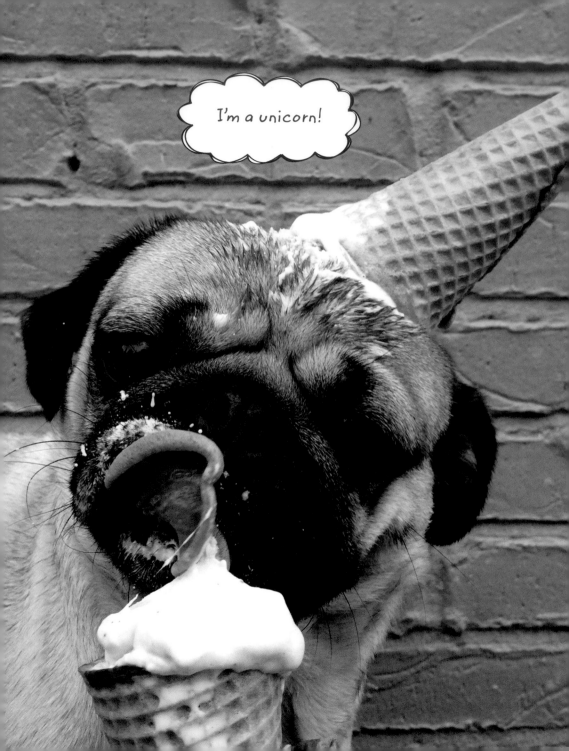

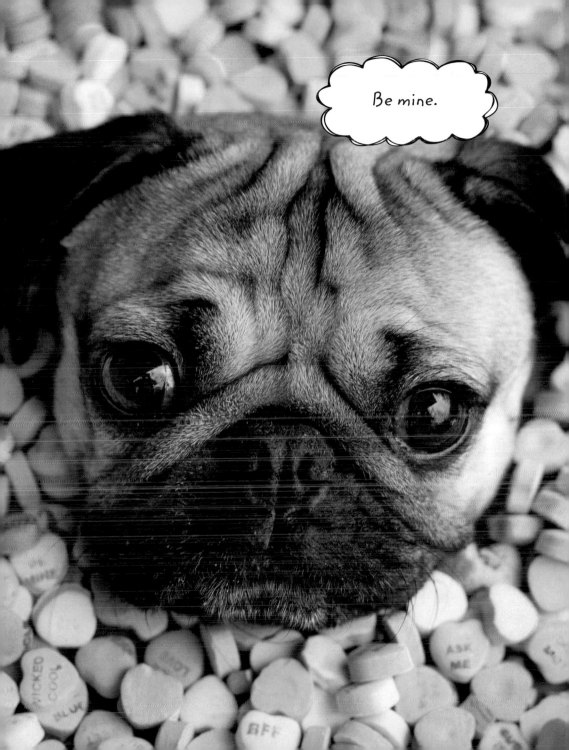

HAVE YOURSELF
A PUGGY LITTLE CHRISTMAS
(AND OTHER HOLIDAY FUN)

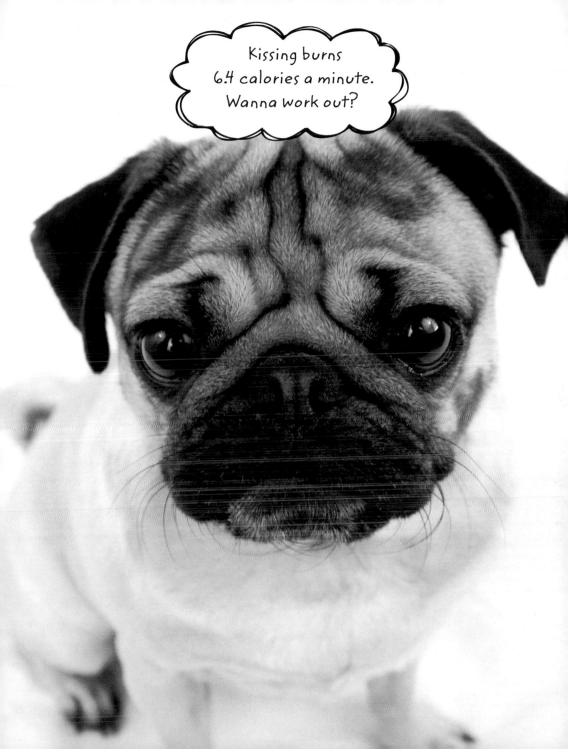

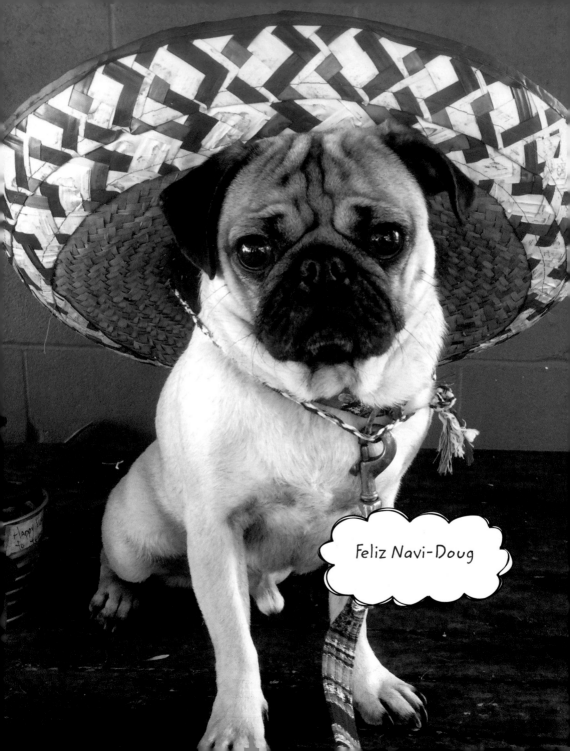

Feliz Navi-Doug

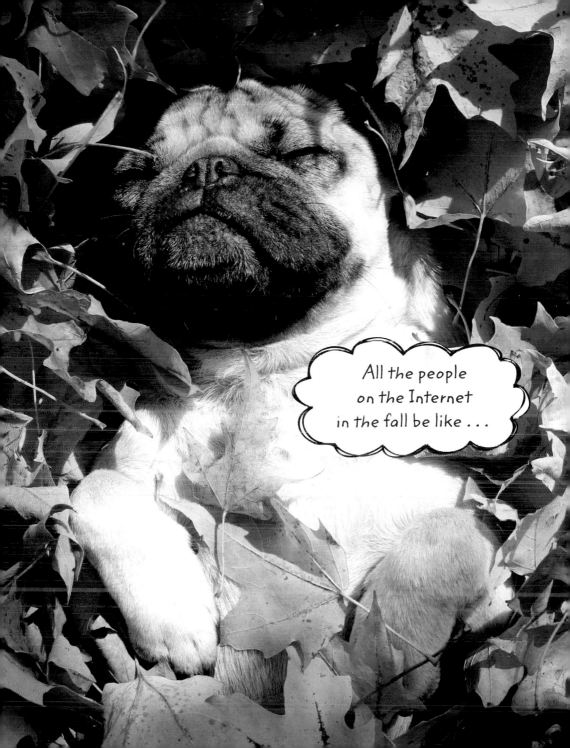

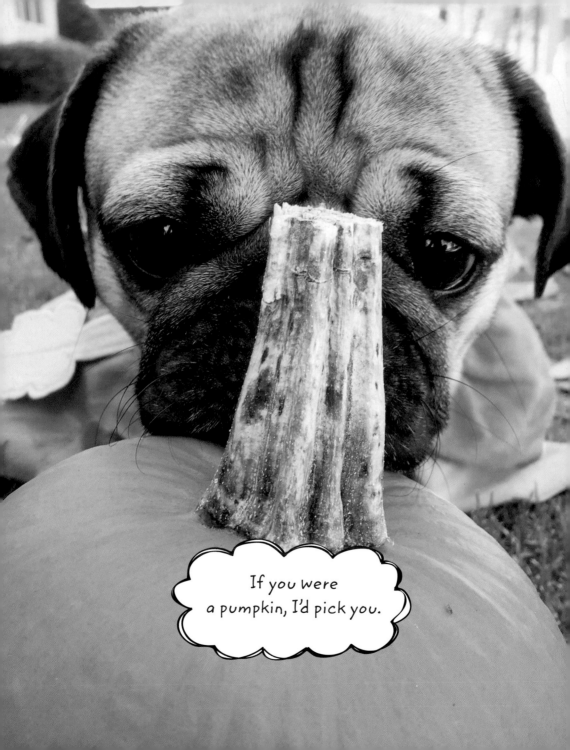

If you were
a pumpkin, I'd pick you.

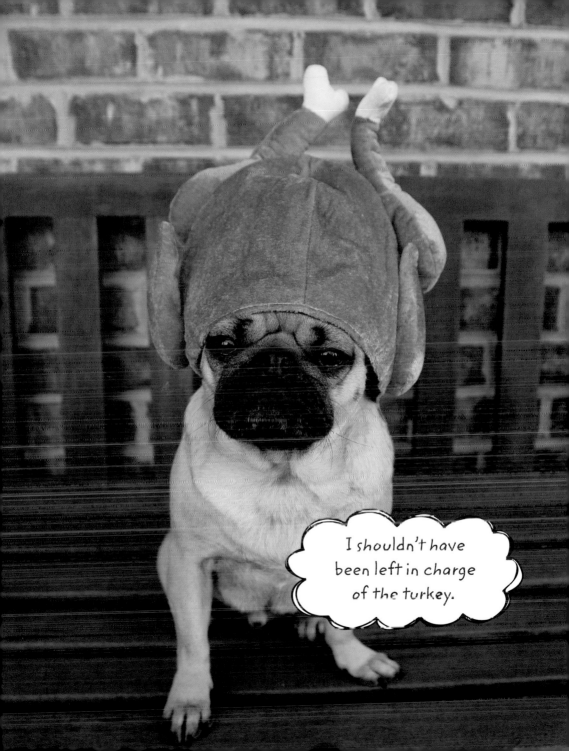

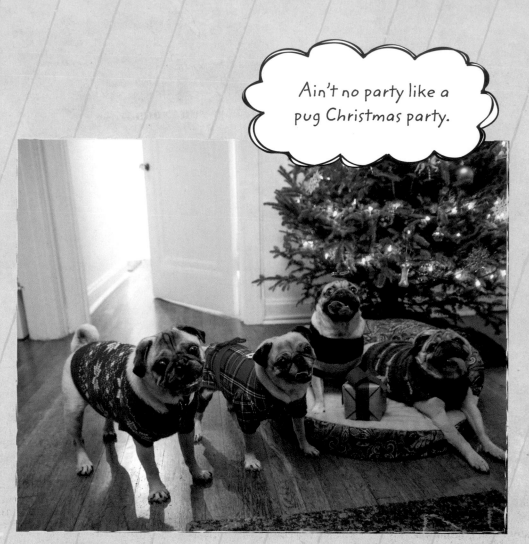

In loving memory of Nushi

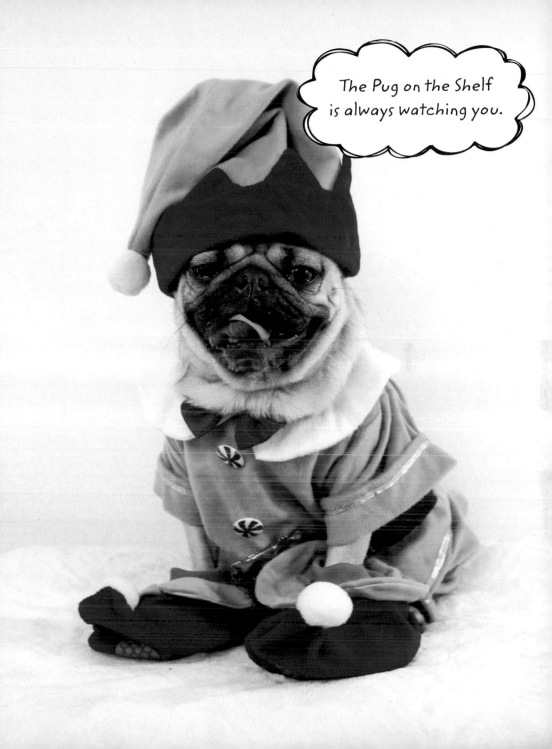

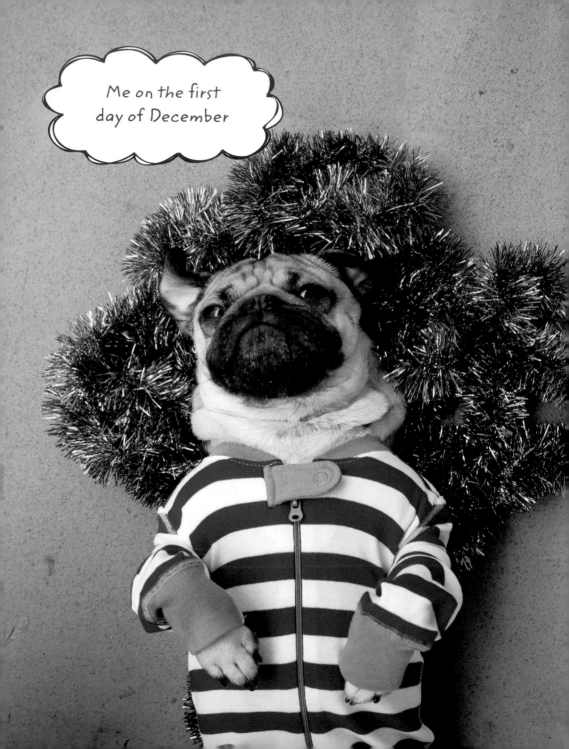

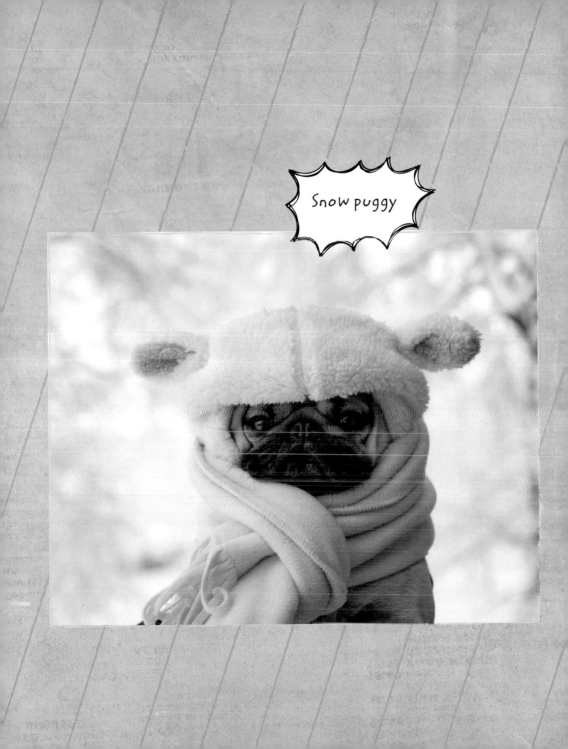

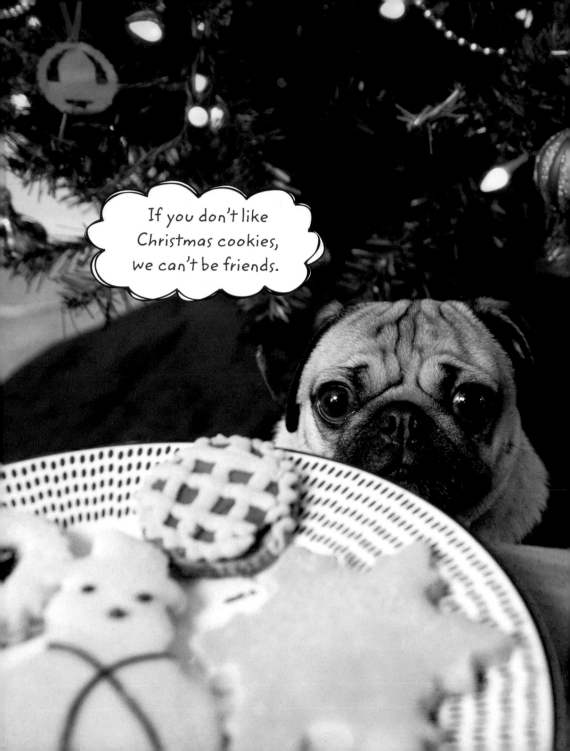

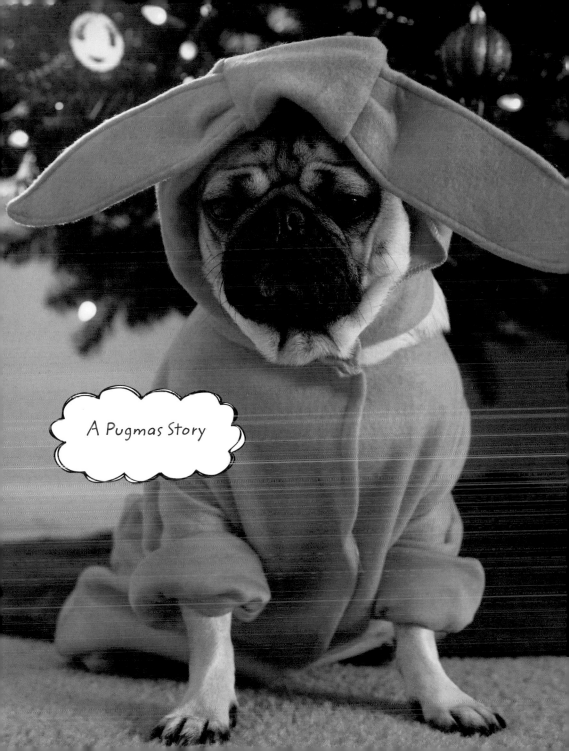

A Pugmas Story

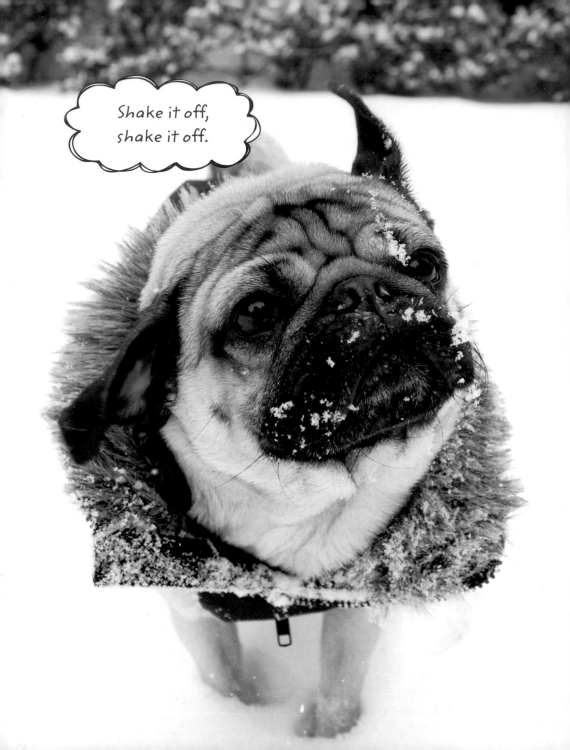

HANGING
WITH MY CREW

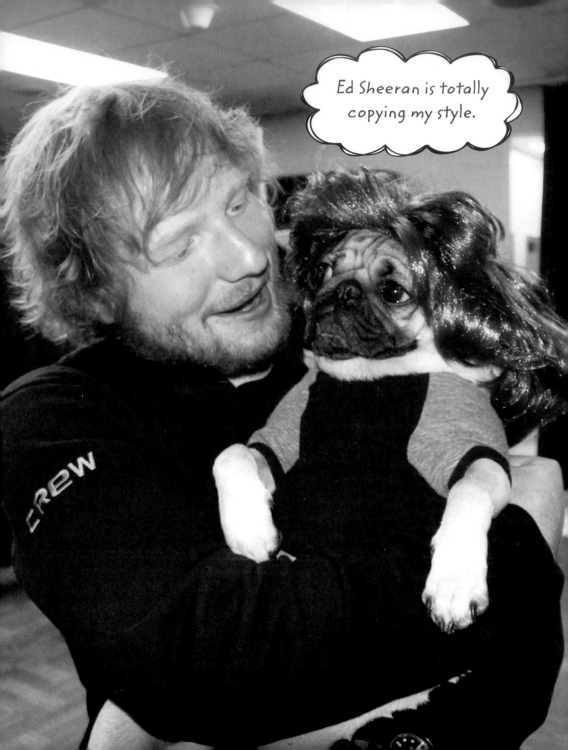

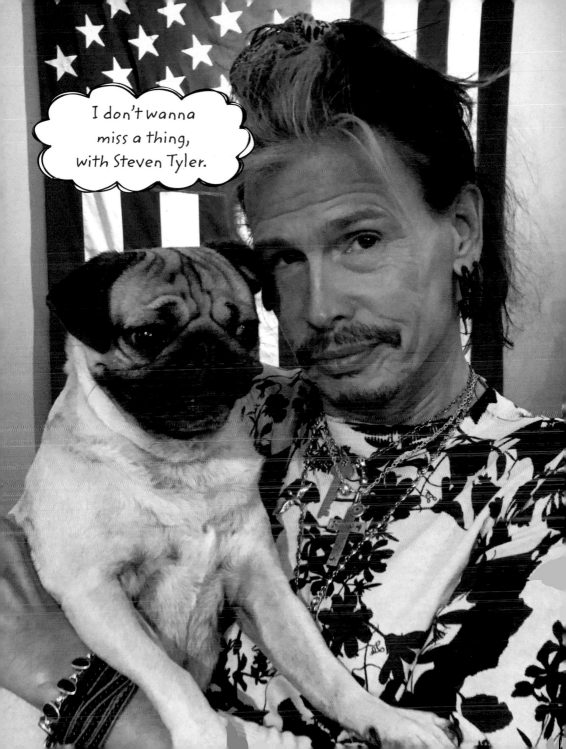

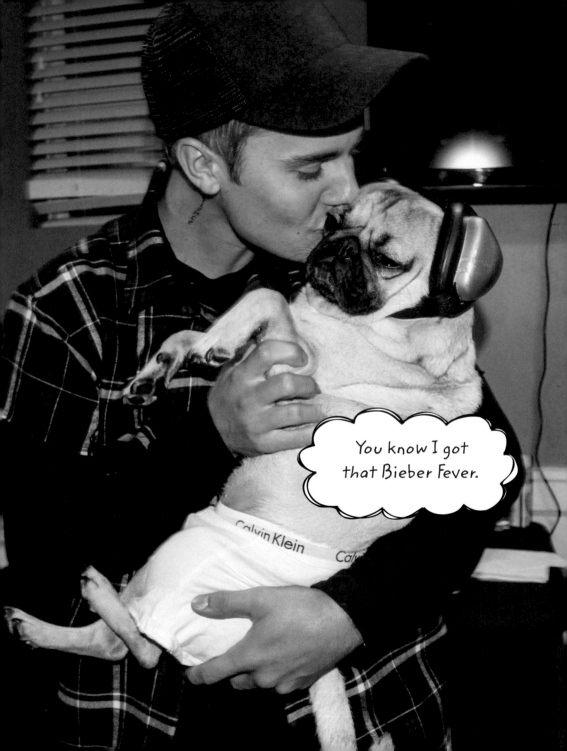

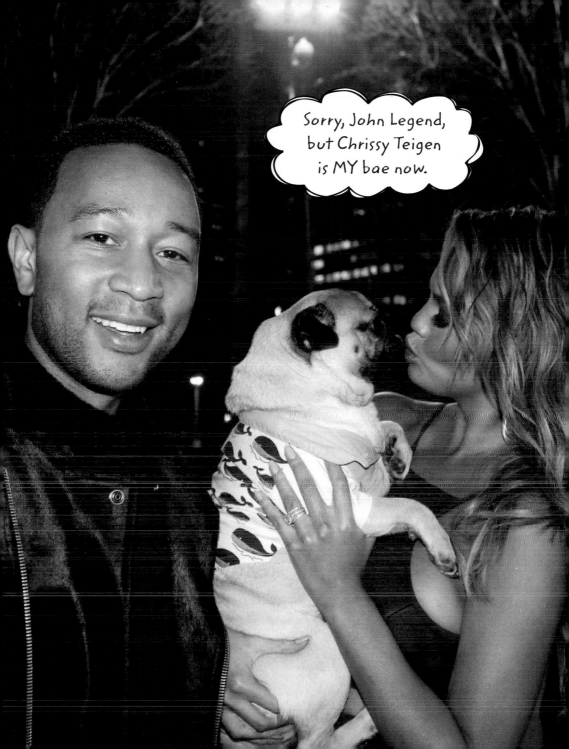

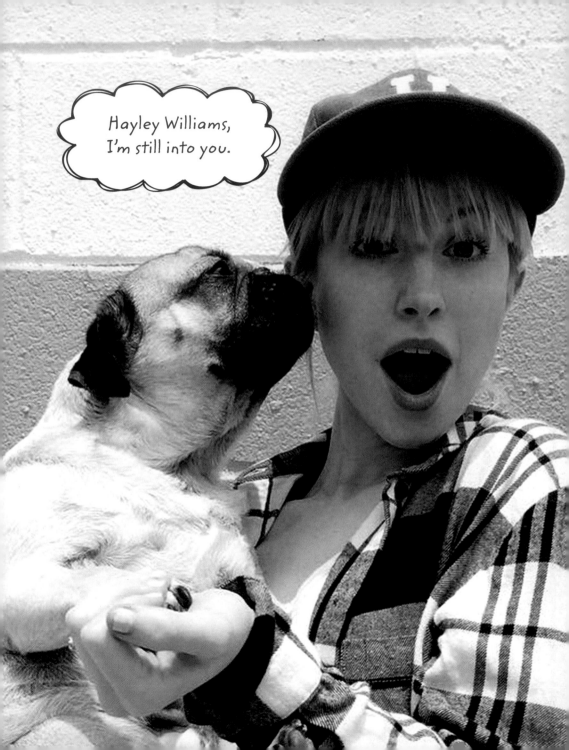

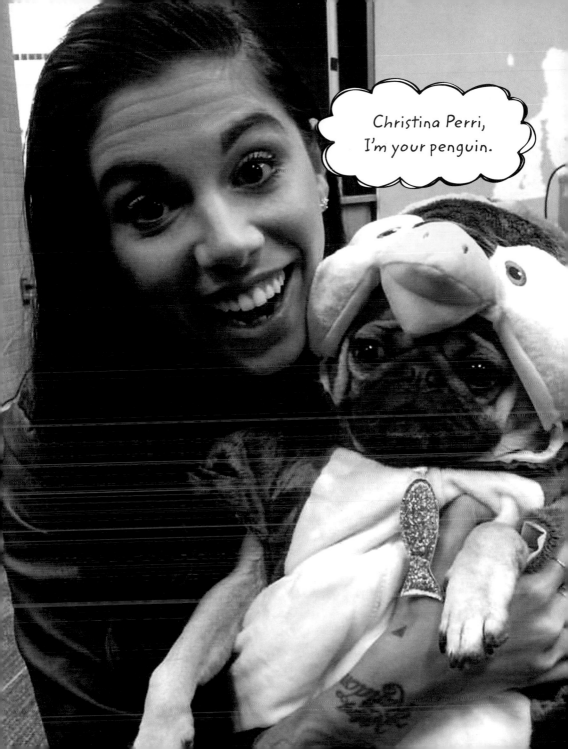

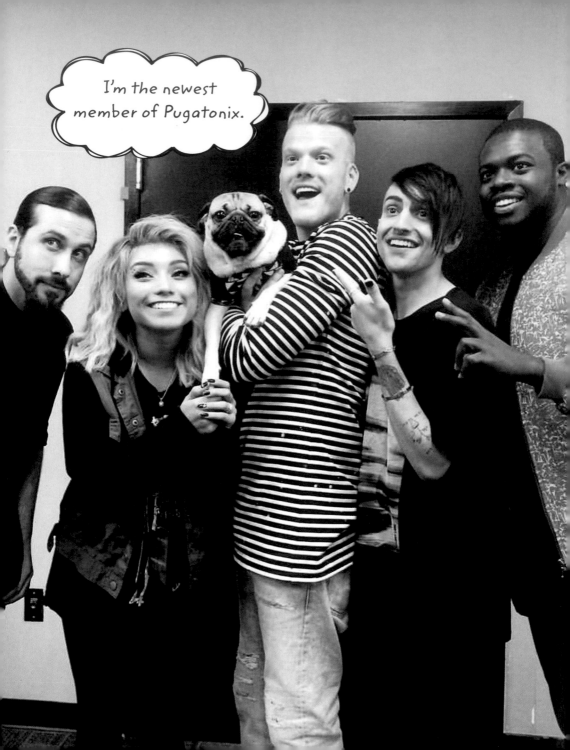

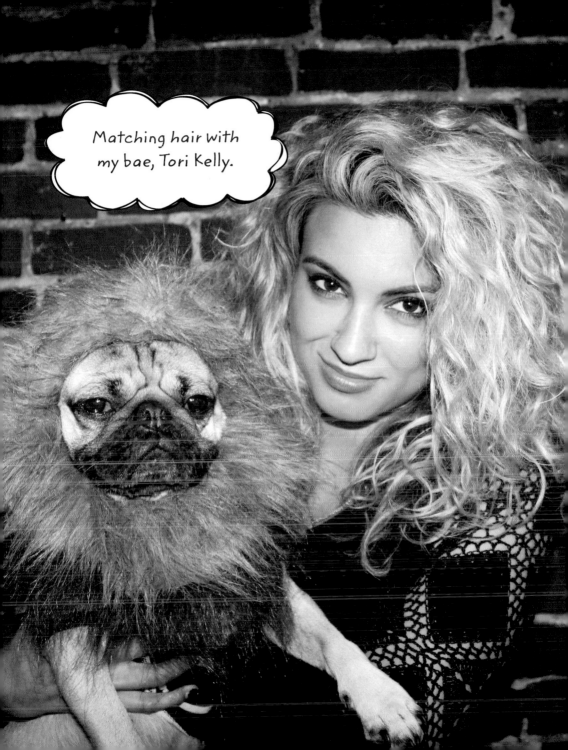

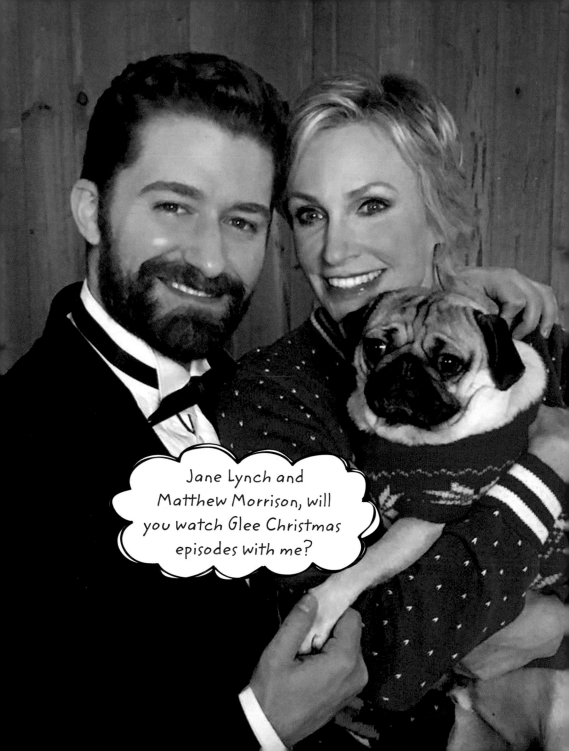

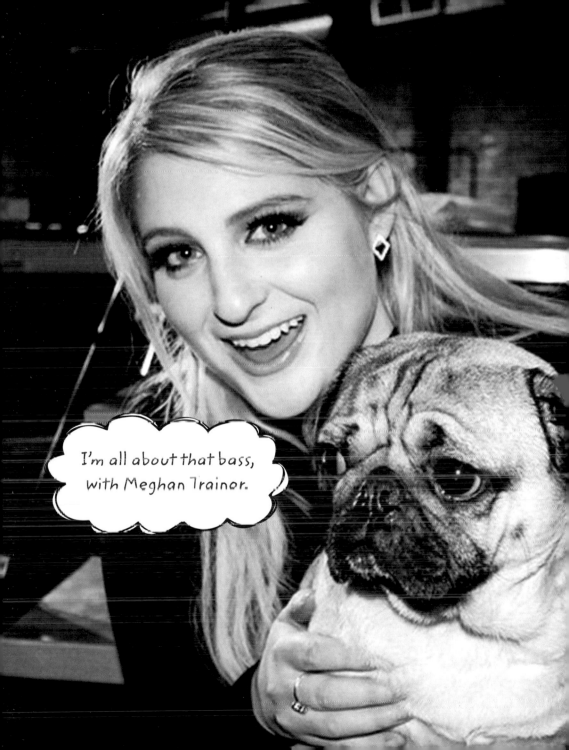

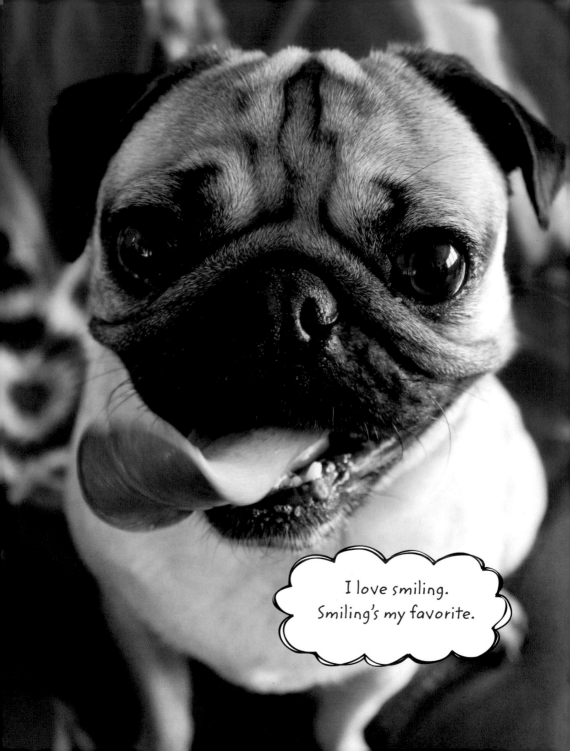

I love smiling.
Smiling's my favorite.

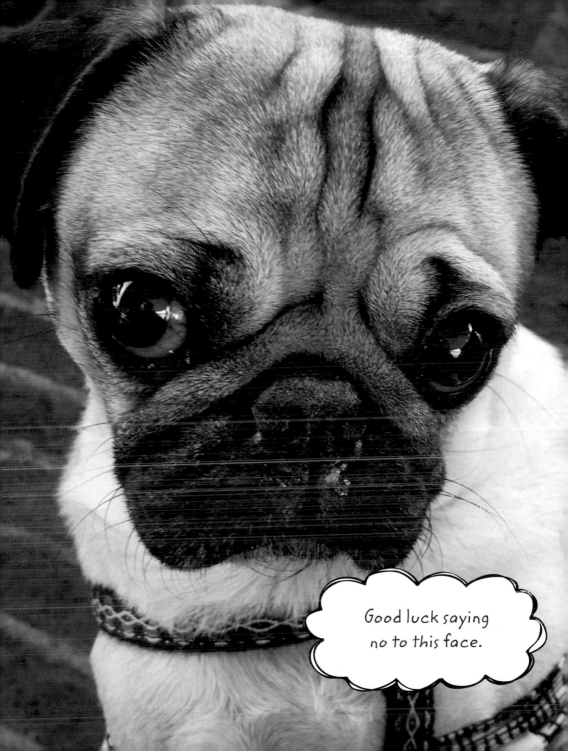

Good luck saying no to this face.

ACKNOWLEDGMENTS

To everyone at St. Martin's and Macmillan, especially Daniela and Lauren, thank you for making a dream of mine come true by being my partners in this crazy journey. I knew from the moment Doug started running laps around the Flatiron building and everyone just smiled and took photos that I had found my literary home.

Jamie Coleman and everyone at Boxtree, thank you for publishing me in the UK, which has always been a dream. I can't wait to visit with Doug.

Melissa, I know you were a match made in literary-agent heaven from our first awkward and hilarious phone call. Thank you for being my biggest champion and always pushing me to be greater. You never fail to make me laugh and realize the bigger picture. Now that this book is out, we need to have a celebratory drink—or three.

Tori . . . oh, Agent Tori. The first person to ever call me and say, "Let me help you." Look where we are now! I can't thank you enough for allowing me to text you like a crazy person at all hours of the day and for getting ramen with us in NYC after a long day of shooting, when I could hardly talk because I was so tired. We've come such a long way, and I owe so much to you.

To Brian Koerber and the whole team at Mashable, the first people to ever take a chance on my little Dougie and introduce him to a worldwide audience; "Thank you" doesn't feel sufficient.

Hadley, thank you for coming onto the Doug team and adding so much joy. You go above and beyond, and we are so thankful for you! Andrew Cook, you're one of the coolest and most connected and loved people I know, and somehow you don't even know it. Thank you for always brainstorming with me and believing in where this could go.

Lauren Robinson, without you I would be so, so lost in the crazy world of money and taxes.

Mindy, Robert, Cheeky, and of course Mrs. Sizzle—my OG New York City crew—thank you for always ensuring that Doug was the best-dressed dog on the block. Because of you guys, he's officially the World's Best-Dressed Dog! Who could've known that our first photo shoot in Nashville would lead to such an incredible and lasting friendship.

Aimee, Carla, Peg—my Nashville pug squad—you guys have been nothing but insanely supportive from the start. I can't wait to have mimosas with you at the next pug party.

Josh Terry, you are a major reason why I am here today. Thank you for being my mentor and teaching me all I needed to know to do this on my own. I couldn't have asked for a better first boss.

Laura, Mike, and Adam at Gersh, thank you for being an amazing team to work with, and, Laura, thank you for being one of the most enthusiastic Doug fans I know (surprise, you get a free calendar this year).

Mom, Dad, and Danny, you're the best and most supportive family I could have ever asked for. You guys are my biggest fans and even though you may have been skeptical when I first told you I was quitting my job to become a dog momager, I am so insanely thankful for all that you've done for me throughout my entire life. Mom, thank you for being Doug's biggest fan (@dougsgrandma on Instagram . . . follow her, it's amazing) and my best friend in the entire world. I love you, Madre. Dad, thank you for helping me on every school project, taking me to piano lessons and concerts, and showing me that weird is cool. Danny, thank you for being the best big brother I could have asked for. I can't wait for your book to come out one day.

To my amazing family—Nana, Auntie Shark, Auntie Kathy, Grandma,

and everyone else—thank you for loving me unconditionally and supporting me no matter what I do. I love and miss you guys so much.

Rob, my everything, there is no one else I'd rather share this crazy journey with. From early-morning flights and long layovers to photo shoots that last all day, you are without a doubt the reason why we've made it this far. I've never met anyone like you, and you are a light to everyone you meet. With that, your entire (gigantic) family also deserves an incredible thank-you: You guys are a crazy bunch but a crazy-supportive and loving bunch. Thank you for inviting me into your family. I love you.

Doug's fans—wow. Thank you for turning my little Instagram account into something amazing and wonderful and for allowing me to pursue my dreams. Thank you for coming to the meet and greets, for your sweet e-mails, and for stopping us on the street to get a selfie with Doug. Without you, none of this would be possible.

All of my amazing friends, thank you for supporting me, cheering me on, and helping me choose between caption A or caption B for a photo. I love you all.

Doug the Pug, I know you can't read this, but since you're practically like a little human, I had to say thank you. Thank you for bringing so much happiness to people around the world. Thank you for teaching me about life and not even knowing it. We have a long journey ahead, bubs.